trace:

<<installaction artspace
cardiff

00–05

edited by andré stitt
foreword by jimmie durham

seren

Seren is the book imprint of
Poetry Wales Press Ltd
57 Nolton Street, Bridgend, CF31 3AE, Wales
www.seren-books.com

Text © the contributors
Images © the artists

First published 2006

ISBN 1-85411-408-5

A CIP record for this title is available from
the British Library

The publisher works with the financial assistance of
the Welsh Books Council.

Printed in Gill Sans Serif and Vagabond by Gwasg Gomer, Llandysul

Contents

<<André Stitt Home is where the art is 6

<<Jimmie Durham An introduction in longhand from Stratford-upon-Avon 10

<<Heike Roms From map to Trace 14

<<season one Alastair MacLennan; Eve Dent; Kira O'Reilly; Jamie McMurry; Lee Hassall, Jessica Buege; Dan McKerrigan; John Boehme 38

<<season two Stuart Brisley; Julie Andrée T.; Brian Connolly; Morgan O'Hara; Warpechowski & Beres 56

<<season three Istvan Kantor; Irma Optimist; Glyn Davies Marshall; Jordan Mackenzie; Hiromi Shirai; Valentin Torrens; James Cobb & Bobdog Catlin; Louise Liliefeldt 68

<<season four James Partaik; Myriam Laplante; Jimmie Durham; Roddy Hunter; Amanda Heng; Jeffery Byrd; Danny McCarthy; Seiji Shimoda 86

<<season five Uri Katzenstein; Julie Bacon; Kevin Henderson; Sinéad & Hugh O'Donnell; Peter Baren; High Heel Sisters; Cyril Lepetit; Boris Nieslony 104

<<annex Clemente Padin; Stuart Brisley; Cosey Fanni Tutti 122

<<collateral Something for the weekend; Rhwnt; Made in China; Of contradiction 130

<<Julie Bacon Beyond histories 142

<<notes on contributors 160

<<trace team 161

<<acknowledgments 162

<<index 165

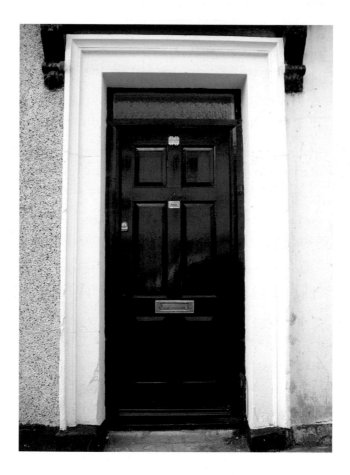

<<André Stitt

Home is where the art is

I heard telephones, opera house, favourite melodies
I saw boys, toys, electric irons and TVs
My brain hurt like a warehouse,
it had no room to spare
I had to cram so many things to store
everything in there

'Five Years', David Bowie[1]

Trace is offered as a significant artspace that represents intersections between artistic disciplines. A place for wider discourse and dissemination of contemporary art practice that seeks to place emphasis on context in the working process. The focus is primarily performative – to explore the previously untried ways of 'thinking' and 'doing' offered by time based art and work that emerges from this field – performance, video, sonic, interactive, installation.

Trace highlights one artist per month. Each artist presents a live investigation with the 'trace' elements of this activity exhibited as installation open to the public by appointment on consecutive weekends during the month. All performances, installations, procedures, live manifestations and actuations are free.

> Trace's slightly ambiguous title as an 'installaction artspace' refers to an amalgamation of 'installation and action-based art'. The exhibition is installed through live performance and once this is completed the installation remains as a documentation and reminder of what has taken place in the room. The art space becomes a container for traces of previous lives, a ghost ship carrying the people and events that have occupied it.[2]

In October 2000 I opened my new house in Cardiff to the public with a performance by the veteran Scots performance artist Alastair MacLennan. Alastair was my teacher and friend when I attended art school in Belfast in the mid-seventies during the dark and dangerous days of the Troubles. So it seemed obvious to invite him to Cardiff for a weekend, do a bit of art and to baptise what I thought was to be my new studio.

I had previously been following a trajectory that included years of squatting in London, creating alternative events, and establishing transient or elusive venues as centres for artistic activity. This previous rather nomadic lifestyle also included jetting around the world making art, meeting amazing people and (painfully) growing up. Supporting these activities included a precarious balance of 'signing-on' and hard labour, working long hours on London's building sites.

What else can a poor Irish boy do, right? My building days came to a thankful halt when I was offered the position of Head of Time Based Art at the art school in Cardiff in 1999. After a lot of soul-searching I left my adopted home in London and bought a rundown house in a deprived inner city area of Cardiff. Converting the ground level of the house (transferable skills!) into what was to be my new studio I thought it looked so good I imagined an occasional gallery. A 'safehouse' for like minded artists to push the envelope. Five years on and just beginning a sixth season of work by invited artists from around the world I find myself curiously counting my blessings. Ok, so I have to rent a studio on the other side of town. It's a source of mirth amongst family and friends. I have to go off to my rented studio, known as 'the shed', while artists come from all over the world to make work in the front room of our wee house in Adamsdown.

The breadth of work that has taken place, the artists and friends who have visited, the meals shared, the fun, the hard work, delight, love and generosity of both artists and public has been liberating and invigorating. Shared experience, common motivation and support, have resulted in a unique place and set of circumstances to create an exceptional experimental exercise in freedom.

> Trace artspace, is a kind of Anarchist Magic Theatre – where entrance is not for everybody – for madmen (and women) only – where you can see art of this nature. Its close relationship to the School of Art & Design's performance art course makes Cardiff a uniquely experimental environment. [It]… is to Cardiff what Albert Hunt was to Bradford in the

late sixties and early seventies; where Hunt sought to capture 'Brecht's affirmation of pleasurable learning, cheerful and militant learning'.[3/4]

All life is meeting

Through Trace, the domestic and private meets the public to create an interface that brings the international and global experience to a social space in the local community.

We invite artists to make time based work in run-down urban Cardiff. Internationally renowned artists come to live and work in the domestic context and to produce work for the public. The work is validated by its existence and disseminated by the imagination of present observers.

Performance art practice over the decades has often been predicated on the notion of meetings: contact and exchange. This process has lead to international networks of artists that form fluid amalgams and manoeuvres in and around existing art systems exemplified in dominant culture. Performance artworks, often identified as time based or ephemeral activities, are always temporary and often influenced by the place and the time in which they occur. As such they draw our attention to the very nature and process of art making and the connection or exchange made in the moment of the encounter.

The context of the encounter or the meeting draws our attention to the temporary, the ephemeral. That reality is not repeatable. So it is with memory, the ghosts of spaces, places, the mind. In my own mind, my memory, I think of Trace – this place, our home – as constant change. The home of many actualities. The traces that are part of the fabric of our home and our lives. The meetings, encounters, exchanges. Friends passing through time and space. We might call it art or collision. Moving about in a world of appearances. It allows for a certain shift; paying attention to the impermanence of things, things to quicken the heart.

André Stitt, Cardiff, 2005

Notes

1 from *Ziggy Stardust & The Spiders From Mars* David Bowie 1972

2 'Let's See Action' Debbie Savage, *The Big Issue*, UK, Feb 2003

3 'The Dark Matters' Graham Domke 2005

4 *Hopes For Great Happenings* Albert Hunt, Eyre Methuen 1976

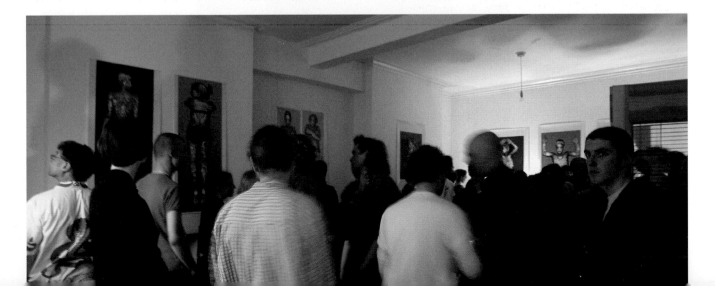

<<Jimmie Durham

An introduction in longhand from Stratford-upon-Avon

[only here for the weekend, to write this text]

Once in New York about twenty-five years ago I watched a Japanese guy from Los Angeles. Here I have had to stop my sentence for about eighteen hours (you, of course, must take my word on that; as you see the printed text you hardly even notice the time involved in whatever it is that has replaced typesetting, much less the fact that I write this in 'longhand' (what a beautifully silly term) and asked a friend to type it out for me).

However I describe the phenomenon with the L.A. guy the words seem awkward: 'He did a performance'? 'He performed a piece'? 'He did a piece'?

Well, he had two hand-puppets. One was a leopard, the other a princess. As he was talking about the leopard it came alive. We in the audience, me at least, did not 'believe' that it was alive, nor did we 'suspend disbelief' exactly, but the leopard came alive and made us afraid and delighted.

Impossibly sad when it killed the princess. I think about that performance piece often, and talk about it.

This year (but maybe you found this book in a dentist's office far in the future) Emmett Williams happily celebrated his eightieth birthday. Some years back he did a piece with his son. Emmett pumped air into an inflatable gorilla. As the air slowly escaped, collapsing the gorilla, young Williams sang a song.

The two pieces I've just written about are not theatrical works, although they just as well could be, if theatre were different. Obviously, they are related to poetry.

I think that we should always bear in mind that categories are simply a convenience. They are not true, not real.

In preparation for a lecture about freedom of work in art I asked a composer friend what might be considered essential for music, after John Cage. Is it rhythm? Sequence? Maybe tone? She replied that there is no essence to music, not even sound or silence. "A painting could be music if the musician were a good enough painter," she said.

We have our western traditions of what constitutes art only from recent times, anthropologically speaking, just over a thousand years. Because these traditions come from cathedral-building (and concomitantly belief-building) the vocabulary is usually architectural. We speak of painting and sculpture as the twin pillars of visual art, for example, and of painting as having a sound foundation.

From the earliest times of this new, seemingly old, tradition, however, individual artists have resented the cage in which it places us. As I can personally reckon during the past forty years and more, about every seven years the magazines announce that 'painting is back'! There are two false suppositions; the first is that somehow good ol' painting somehow withered under the unjust glare of newer art forms. The second is that painting is the foundation of visual art. The 'return to painting' always seems to me to be similar to the 'return to good old-fashioned family values'.

We might be better off if we could discard this lie of convenience called 'art' altogether.

The architectural foundation for visual art is the monument. When the monument is a painting it is of the kind called 'masterpiece'. These things strive for the power to present themselves to us unarguably.

As many others have written, contemporary culture often wants something more intellectual. It is not painting or sculpture that contemporary artists object to. For me it is the comfort and belief in painting. For me 'intellectual' means against belief, towards curiosity, away from clear answers, towards a kind of confusion that puts certainty and satisfaction in abeyance.

Ireland and the U.K. have produced extra-ordinary performance artists whose work makes the monument lose its shadow. Work that comes and goes in the space of minutes and then reverberates and echoes without weight. Among these are Rose English, Gilbert and George, and André Stitt. Maybe it seems inappropriate to mention Stitt in this context, but he is, after all, the spirit behind Trace, so it could be really inappropriate

to leave out his performance work. His work is intensely focused, but we do not always see where he as the performer is focusing. It looks as though he sees a sad complexity of landscapes in war and is mapping possible escape routes.

No, no, be careful now; that is not hyperbole, it is only that I try for poetics. To speak more practically, it seems that there is no separation between Stitt's art practice, teaching, and the operating of Trace. This shows up well in the energy of Trace as a centre for performance and time based art.

What a good space it is. It occupies what otherwise would be the front room of André Stitt and Eddie Ladd's small house in Cardiff. We can imagine a time soon when it will have its own space, still, most likely, not exactly a gallery space, not exactly a theatre space.

As it is now, whether or not you are fortunate enough to catch someone's performance, the next day and the next you can study the traces that are left. These are usually not 'art' in the sense of discreet, potentially-commercial objects. More often they are like the performances, not exactly belonging to our quotidian lives but giving good counsel all the same.

That Trace is in Cardiff is excellent…

Jimmie Durham, 2005

Jimmie Durham
"Under Construction"

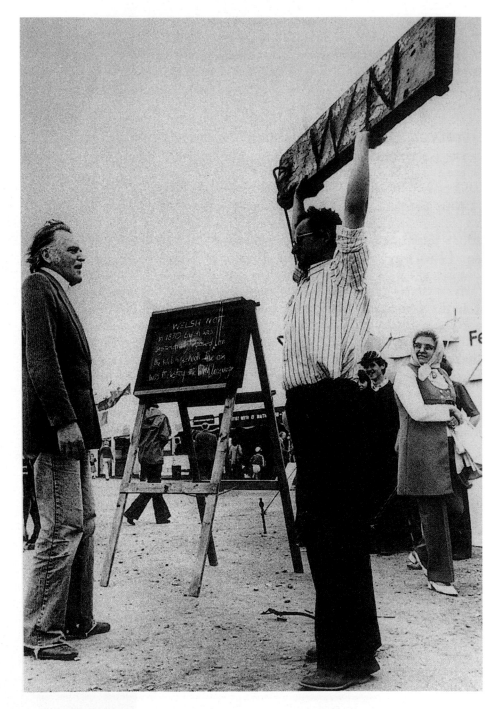

Paul Davies at the National Eisteddfod,
Wrexham 1977, Photo: Vera Davies.

<<Heike Roms

From map to Trace
Situating performance art in Wales

The first thing that struck me when I moved to Cardiff, Wales' capital city, many years ago was the extent of its terraced houses, which crawl like stony snakes up and down its many streets. On one of these streets, a short walk away from the gentrified city centre in a rougher part of the town, stands 26 Moira Place. Initially there is nothing remarkable about this house: black-and-white pebble-dash exterior, peeling black paint on windows and doors, it looks indistinguishable from its neighbours. Only a small brass plate engraved with the word Trace above the doorbell hints at the house's hidden identity. Here in October 2000, in the middle of a residential area in close proximity to the city's art college, André Stitt opened Trace: installaction artspace, housed in the front room of what is still his home. Under the curatorship of Stitt, himself one of Europe's foremost performance artists, Trace's small living-room gallery has since established itself as an internationally renowned art space and the only venue in Britain that focuses exclusively on time based art and work that emerges from this field – performance, video, sonic, interactive and installation arts.

Every month, a different artist presents a live performance, with the 'trace' elements of their activity exhibited as an installation on the following weekends. The first challenge to artists is thus to experiment with their own practice in the focused set-up of a single-artist show; the second is to consider how the residue of their work may continue to exist and evolve beyond the performance. In its first five years Trace hosted 43 artists from 22 countries in 41 events – among them some of the doyens of performance art, such as Alastair MacLennan, Stuart Brisley, Zbigniew Warpechowski, Jerzy Beres and Cosey Fanni Tutti, as well as emerging artists, including Jessica Buege, Julie Andrée T. and Eve Dent. Its programme is based on Stitt's extensive networks, developed through making performance work for over 25 years in many locations in the world. At the heart of Trace is the idea of encounter that is so central to much performance art, an art practised by

individual artists yet deeply attracted to ideas of community and exchange. Trace has explored such encounters also through formalised international exchanges with other spaces and festivals devoted to performance art (e.g. with Le Lieu in Québec (Rhwnt 2003/4) and with the DaDao Live Art Festival Beijing (2004 and 2005)). Even among these artist-led initiatives, Trace seems unique. Its domestic setting, central to its functioning, has created a distinctive model of how art can be housed, how performance may be encountered by the people who watch it, and how performance can leave traces that secure its survival. This has become the foundation of the gallery's influence, not least on the performance art scene in Wales.

The following article attempts to trace this influence by firstly mapping the field of performance art in Wales before offering a personal account of the contribution that Trace has made to this field. This perspective can admittedly only offer a limited insight into the richness of the themes and artistic strategies that the artists have explored. To them my apologies.

Part One: What's the Welsh for 'performance'? – 40 years of action art in Wales

The history of performance art in Wales has yet to be written. Over a period of almost forty years artists have been creating performance, action or time based art in this country, yet their work remains largely confined to oral history, to half-remembered anecdotes, rumours and hearsay. Yoko Ono allegedly

once presented an action at the National Museum in Cardiff; the small seaside town of Aberystwyth is said to have hosted a Fluxus Festival... One searches in vain for traces of these events anywhere. It's surprising for a discipline so committed to documentation and theoretical reflection, there are no archives dedicated to performance art in Wales, no books, no journals. Rather than constructing a history from such fragmentary evidence therefore, for the purpose of this article I will attempt to provide a kind of geography instead, a map of Welsh performance's many manifestations in the past and present. This map features a series of sites, locations at which performance actions have actually taken place but which, more importantly, have also served as conceptual locales around which performance in Wales has been created. These sites may be called, after Foucault, 'heterotopias':

> real places – places that do exist and that are formed in the very founding of society – which are something like countersites, a kind of effectively enacted utopia in which the real sites, all the other real sites that can be found within the culture, are simultaneously represented, contested, and inverted. (Foucault 1986: 24).

In Wales, such heterotopias include 'Y Maes' (The Field), 'Y Tir' (The Land), 'Y Ddinas' (The City), 'Y Rhwydwaith' (The Network) – and 'Y Tŷ' (The House).

Mapping performance in Wales

The distinctiveness of much Welsh performance work derives from a fusion of global artistic developments with local cultural and political desires. The earliest art actions that appeared in this country in the late 1960s and early 1970s were inspired in equal measure by the movement of the international avant-garde toward a dematerialization of art practice and by the local reaffirmation of a distinct cultural identity that manifests itself primarily as performance (above all as the celebration of the Welsh language). This was accompanied by a political activism that too gathered pace in the sixties through harnessing performance's radical potential for direct political action in the struggle for the survival of the language. Wales has often been called 'England's first colony' – a marginalised culture turned to a marginal art practice as a means for its cultural and political expression. As a consequence, the division between different artistic disciplines has been of lesser importance than the question of where these disciplines situate themselves in the cultural and political landscape of Wales. In its quest to develop a distinctive form that could provide an alternative to the dominant English mainstream, for example, Welsh experimental theatre from early on embraced artistic strategies that we have come to know from performance art, such as site-specificity, duration and active audience involvement. As a result, the term 'performance' in Wales today describes a fluid field of innovative practices originating in a variety of disciplines, including performance art, sonic art, experimental theatre, movement work, and performance poetry. It is this interdisciplinary quality and the 'sited' nature of Welsh performance in an international field of highly nomadic practices that distinguish the performance scene in Wales.

Y Maes – The Field

> The timetable of the whole event and the nature of the performance was ... interrupted by an impromptu happening after Mario Merz had completed his piece for piano, lazer [sic] beam, rose and coal sacks. He moved towards Paul Davies who at that moment was holding something like a railway sleeper above his head. On it were burnt the letters

'WN' ('Welsh Not') which referred to the punishment for speaking Welsh in school enforced within living memory. As it happened the chorus of the national anthem was coming through the loud speakers and although Merz does not understand Welsh he gave out phonetic improvisations as he moved around Davies. Paul Davies had already had an argument with a middle-aged man who had emigrated from north Wales to New Zealand and was now accusing the native artist of 'stirring it up'... It showed too that Davies possesses a power of feeling which he expressed both symbolically and in argument and which was most relevant to the Eisteddfod. He felt enough to be a kind of flagellant.

In a year prominent for its Union Jacks (1977 was the year of Queen Elizabeth II's Silver Jubilee) he was inventive enough to wrap himself in that flag and then to struggle out of it. I heard comment elsewhere that both the Coronation Jubilee [sic] and the National Front [a far-right political party] had produced better performances than those at Wrexham. But politics aside, such things depend on financial backing and critics express double standards with regards to this. But the *South Wales Echo*'s 'What a Shocking Waste of Money', and what the *Daily Express* called 'The Fine Art of Wasting Money' as well as the *Daily Telegraph*'s more conservative hint that 'Wall Stunt Starts New Grants Row' only serve to register a higher record than would a polite review in the arts column. (Ivor Davies, 'The Welsh Arts Council's Performance Pavilion at the National Eisteddfod', in *Link* 9, Autumn 1977; reprinted in Bala 1999, p.66)

In ways more than one, Paul Davies' (unofficial) appearance at the National Eisteddfod in Wrexham in 1977 can be regarded as a seminal event for contemporary Welsh art. Critic Shelagh Hourahane has called Davies' action, Spiral Gag, in which the artist struggled free from his symbolic imprisonment in a British flag, 'the inception of a self-conscious contemporary Welsh political art' (in Bala 1999, 79). The act can also be considered the inauguration of a self-conscious Welsh performance art. Performance art had evidently been made in Wales before – artists Rob Con and Ian Hinchliffe, for example, had created a series of joint street actions around the country in the mid-seventies, among them a performance in the Brecon Beacons National Park during a snowstorm; well-known English performance practitioners Roland Miller and Shirley Cameron had created work in the context of the famous Barry Summer School, which from the late-1960s offered courses in fine art and improvised jazz based in a small port on the outskirts of Cardiff; and Welsh artist Ivor Davies, painter, activist and protagonist of the Destruction Art movement, had staged happenings in Swansea as early as 1968. Paul Davies was probably the first artist, however, to utilise the idiom of performance in order to articulate within a simple symbolic action a complex nexus of issues concerning cultural domination and political resistance that commented very directly on the Welsh situation. As fellow artist Iwan Bala, like Davies a member of the Welsh artist collective Beca, claimed for the work of the group:

[Beca] was the instigating force in the politicisation of Welsh art, and one that focused international trends and methodologies into a language that highlighted specific concerns in Wales. (Bala 2003, 23)

In Davies' case this focus was expressed in the language of performance art. The location at which the event occurred is hereby highly significant: the National Eisteddfod (Eisteddfod Genedlaethol) is one of the oldest, most poetic and most political European festivals. The word 'eisteddfod' literally means 'sitting' and originally described a medieval contest of poets with rules and prizes. These days, the National Eisteddfod has grown into a week-long festival of Welsh culture to which the Welsh-speaking community makes a pilgrimage en masse each year. This is not just the place where awards are given for rhyming and singing, but also where books, records and political campaigns are launched, and where, over the years, the visual arts have enjoyed an increasingly high profile. I can think of few other occasions at which innovative art and conservative folklore, radical politics and cultural traditions co-exist in this way. What seems to hold this eclectic mix together is an acute awareness of the

performative nature of Welsh culture in all its facets. What the Welsh themselves refer to as 'y pethe' (the things), considered to be central to a traditional Welsh identity, such as religious singing and preaching, oratory, poetry recitation and choral song, have always been thought of as inherently performative, and they are all still celebrated at the Eisteddfod today, as are their contemporary equivalents of pop music, poetry slam and political speech. It is to these cultural performances that Welsh-speaking artists in particular turn time and again as material for their work. Poetry reading turns into political demonstration leads to art action – their difference is often impossible to identify in the highly performative context of the Eisteddfod.

Even the format of the Eisteddfod has a performance dimension. There is no fixed location for the festival; instead it travels up and down the country, each year located at a different site, alternately in the north or the south. All activities take place in a makeshift village of pavilions, tents and stalls. The Welsh term for this site is 'Y Maes' (the field): peripatetic and provisional, ephemeral and decentralised, the Eisteddfod Maes is more a conceptual place than an actual location. The term has obvious connotations in the traditionally rural economy of Wales, but it also resonates with ideas of openness and (as in 'field-work') with the close anthropological study of culture. As such, the 'field' as trope has figured in much Welsh performance work, on and off the Maes. The Eisteddfod in 1977 was the first time that performance art was officially represented at the festival – and the outrage that Merz's and Davies' work created meant that for a long time it also remained the last. But performance art has nonetheless retained a presence at the festival, sometimes within, sometimes outside its official structures. At the Eisteddfod in Bro Dinefwr in 1996, for example, Welsh experimental theatre company Brith Gof decided to ignore the sanctioned spaces for presenting art work on the Maes and hired a commercial stall, where they showed a durational performance over five days, which became infamous for its use of male nudity. Since 1994, Cywaith Cymru. Artworks Wales, the national organisation for Public Art in Wales, has commissioned a special project, usually with a performance focus, at the Eisteddfod every year. Some of the most innovative arts practitioners working in Wales today have in recent years received commissions to create work for the Maes These include André Stitt (who performed a walkabout on the Maes, holding a sign with the words Fi'n Dy Garu Di (I Love You), making encounters and exchanges with the people he met), Peter Finnemore (who installed a shed on the site that became a venue for alternative ceremonies to the official pomp and circumstance of the Eisteddfod), Simon Whitehead (who presented Cysgod, an audio walk around the festival led by a horse) and David Hastie.

Much of this work has centred on the question of language. In Wales, where only around 20 per cent of the population still speak Welsh, the survival of the language has become a daily struggle. Again, it was the Beca group, this time led by artist Tim Davies, who expressed this struggle in a performance piece at the National Eisteddfod in Bro Colwyn in 1995. In an outdoor performance/installation event lasting eight hours, participants took it in turns to recite sounds of the Welsh alphabet

which, for them, were imbued with particular associations, while Davies ritualistically burnt these 'ineffable symbols of sound' on to large squares of woollen blankets which, as they were completed, were displayed around the stage.

(Martin Barlow in Bala 1999, 152-3).

Davies, who comes from a Welsh-speaking background but does not speak the language himself, attempted to engage

with that elusive spirit hidden within the letters of the language that he himself has lost. (Bala 1999, 156).

Y Tir – The Land

The mountain range appears, white and gleaming, against the fading light as dusk sets in. A thunderous rumble in the far distance warns of a storm approaching. The glowing red ball of the sun vanishes slowly behind the peaks, bathing them for a moment in its orange beam. We are witness to a glorious sunset in the uplands of the Llyn peninsula in north Wales. Only we are sitting, neatly packed in rows, inside the black-box auditorium of a theatre space. The mountains are formed from crumpled strips of white paper. Moments ago movement artist Simon Whitehead had used them to scribble down memories of a walk across the landscape of the peninsula. Now he is standing next to the paper panorama, moving a red light bulb slowly from one side to the other to illuminate the scenery, whilst his collaborator, sound artist Barnaby Oliver, mixes the sounds of nature with those of technology.

Whitehead's 'folc-land' from 1997, subtitled 'The long lines project – a landscape re-envisioned', was one of the first of a growing body of work by a new generation of artists working in Wales today who create performances from their physical, sensual and emotional response to the Welsh landscape. Their work is located within a long tradition: in Wales identity has been linked historically, culturally, politically, linguistically, socially, emotionally and aesthetically to its landscape. As a result, in the area of the visual arts, 'landscape painting has been syn-onymous with Wales for a long time' (Bala 2003, 30). This was firstly

> mainly a Romantic ideal, painted for tourists by touring artists like Turner, Sisley, Sutherland, John Piper and Paul Nash, [a form of] colonisation of Welsh landscape through art. (Bala 2003, 29)

More lately in works by contemporary painters from Wales such as Catrin Webster, Peter Prendergast and

Simon Whitehead, '2 miles an hour (a pace for walking in rough country with cattle and sheep)', en route in Wales, Photo: Pete Bodenham

Iwan Bala, who aim to reclaim the pictorial representa-tion of the landscape of their home.

In Welsh performance work, this landscape has been explored with an aesthetic that has its roots in the time based strategies of land and environmental art and in an ecological concern for rethinking our connection with nature. Whitehead has created a series of 'mapping' performances based on long solitary walks through the Welsh landscape, informed by a sense of estrangement and the desire for a sensual and per-ceptual reconnection. Whitehead is also a member of the 'ointment' collective (with Stirling Steward, Pete Bodenham and Maura Hazelden), a group of artists based in west Wales, who have staged 'place-sensitive work' in rural sites, inspired by an ecological agenda, local folk traditions and the decline of the farming economy. Another artist whose psychogeographical performance work is often based on the practices of walking and mapping is Cardiff-based performer Phil Babot. In his recent 'The Long Road to the North,' a journey from the southernmost tip of Wales to its northernmost point, he followed magnetic north and created occurrences and interventions en route, accompanied by the creation of solo art works alongside collaborations with four other artists who

live in varying geographic locations northwards along the designated path.

The first instalment of Babot's year-long project took place in 2002 at Coed Hills Rural Artspace (CHRA), a 180-acre farm in the Vale of Glamorgan in South Wales, which is run by artists who attempt to reconcile the making of contemporary art with ideals of sustainable living. They have transformed the farm into an art space with purpose-built studios, low-impact dwellings for visiting artists, a sculpture trail of site-specific works and a programme of exhibitions, performance festivals and community workshops. The project is sustained by a host of on-site small businesses, including an organic café, wholefood distribution, lime putty production and greenwood handcraft – the Welsh Assembly recently appointed CHRA a model for sustainable development.

Not all artists in Wales who share an interest in working in and from the land, however, are primarily motivated by such ecological or perceptual concerns. There are a number of those whose work has centred instead on social questions of community, on political issues of land use and ownership, or on personal matters of identity. Rawley Clay, founder of CHRA, spent three months in the small village of Beddgelert in the heart of Snowdonia in 2002, working alongside and with the local community, offering them his services as a 'village artist', a new addition to the local economy. Performer Eddie Ladd, who comes from a Welsh-speaking farming background, returns time and again in her work to the location of her upbringing. But Ladd's performances are as much shaped by contemporary media influences as they are by traditional rural culture (recent works referred to the Western *Shane*, Brian de Palma's *Scarface* and Samuel Fuller's *Shock Corridor* and stories of rural landslides, the Welsh dairy industry and the theme of terrorism). Ladd shows how ideas of self-containment and stability are replaced by erosion, fragmentation and cultural self-loathing.

The rural landscape of Wales, however, presents only one part of the country's environment. South Wales in particular is highly industrialised, and the industrial landscape of the so-called 'South Wales Valleys', the site of the former coal and steel industries, possesses an iconic status comparable to that of the Welsh mountains of the Romantics. In the works of many artists of the late nineteenth and early twentieth century 'there was a sense of the 'picturesque' transferred from unspoiled 'heavenly' landscape to 'infernal'; from paradise to paradise lost'. (Bala 2003, 30). Today little of this landscape remains – factory buildings have been knocked down and slag heaps greened over. There was a short spell in the 1980s, however, when the abandoned architectural remnants of Wales' industrial past were seized temporarily by site-specific theatre and cross-disciplinary performance work. The most prominent of these was Brith Gof, the pioneers of site-specific theatre in Britain, who staged works in railway stations (*Pax*, Aberystwyth 1991), disused car factories (*Gododdin*, Cardiff 1988) and abandoned iron foundries (*Haearn*, Tredegar 1992). These buildings have since made room for the anonymous sheds of the new call-centre industry. But the psychic landscape of South Wales, with its concomitant symbols of hard physical labour and aggressive masculinity, remains a strong presence. Gay performer and dancer Marc Rees, for example, who worked as a performer with Brith Gof for many years, creates performances and actions that revolve around the negotiation of his sexuality between the intimate childhood landscape of his upbringing in south Wales, a world steeped in conservatism and rugby-machismo, and his current life in the 'queer' landscape of the city.

Y Ddinas – The City

In 1955 Queen Elizabeth II declared Cardiff to be the capital of Wales. Cardiff is the country's largest city (around 320,000 inhabitants) and thus seemed an obvious choice. But Swansea

and every other major town in Wales had laid claim to becoming the capital, and most of them had better historical justification for their claims. In their eyes, Cardiff was a town without a past, a nouveau riche fishing village which made a career for itself in the 19th century as a coal port, and did not even receive a town charter until 1905.' (Sager 1991, 93)

Cardiff is also Wales' most anglicised city, geographically and culturally located in close proximity to England. And as a port it has always maintained stronger links with the rest of the world than with its Welsh hinterland, which for many called into question its suitability as a capital. The dispute was revived again in the wake of the so-called 'devolution': 1999 saw the creation of the National Assembly for Wales, a somewhat historic achievement in that it gave Wales, which up to that point had been governed from England, its own executive forum for the first time in six centuries, albeit one with restricted powers. When searching for a fitting location for the Assembly, Swansea and every other major town in Wales again laid claim to becoming the seat of government, but in the end the city of Cardiff won out.

In 2005 Cardiff celebrated its centenary as a city and fifty years as the Welsh capital. It was the town's ambition to follow this by becoming European City of Culture in 2008, but it narrowly missed out to its competitor Liverpool. Cardiff's campaign for the competition, however, briefly energised the local arts scene and inspired a debate on the nature of urbanity and the artist's place within it. It also highlighted the major changes the city had undergone in recent years. Cardiff, once a thoroughly anglicised and over-whelmingly working-class town (and as such with no real tradition of a public patronage of the arts) has been gentrified by a new middle class, many of whom are Welsh-speakers employed in the media and government. Symbol for the change is the Bay area, where, adjacent to the neighbourhood that still houses one of the oldest multicultural communities in Britain, one of Europe's biggest waterfront developments now attracts new upwardly-mobile customers to its chic bars and restaurants. But the accusation of a cultural apartheid between a Welsh-speaking elite, an English-speaking second-class proletariat and various disenfranchised multi-ethnic groups ignores the far more complex interplay of different communities, languages and economies that make up the cultural life of the city, and that presents the context in which many socially-engaged artists in Cardiff create their work.

For some, of course, the very idea of 'Cardiff as City of Culture' is already an oxymoron – for this is the city in which Zaha Hadid's daring design for the Cardiff Bay Opera House won an international competition in 1994, but was turned down by the financiers. The ensuing scandal won Cardiff an international reputation as a city of philistines, a reputation it recently confirmed when architect Richard Rogers was first hired, then fired, then hired again to design a new home for the Welsh Assembly. Cardiff has one of the best schools for architecture yet little contemporary architecture of any note, and one of the best art schools in the country yet (at present) no publicly run contemporary art space. (There are a number of Welsh galleries devoted to contemporary art outside the capital, in towns such as Swansea, Machynlleth, Aberystwyth, Wrexham, Llandudno and Newtown. Plans to open a major new visual arts facility in Cardiff, the Depot, have currently stalled, but the success of the Cardiff-based Artes Mundi, the largest prize for visual art offered anywhere in the world, awakened a new public interest in contemporary visual arts after its launch in the spring 2004.) In the absence of large public institutions, the critical mass of artists involved with contemporary art in Cardiff thus takes the form of independent artist-led centres, collectives and networks.

The Cardiff School of Art and Design (or Howard Gardens as it is familiarly known) has for many years offered students the opportunity to specialise in time-based art practice (i.e. performance, video, sonic and installation art) as part of their fine art degree. Teachers

and students affiliated with the school have consequently occupied a central position in the performance art scene of the city. For a number of years the time based department was led by poet and performance artist Anthony Howell, founder of the influential Theatre of Mistakes, with whom in the 1970s he performed Fluxus-inspired minimalist 'conceptual performances' based on rules and instructions. During his time at Howard Gardens, the school housed Cardiff Art in Time (CAT), a performance art and video festival, which took place in 1995, 1996 and 1999 and featured student and professional work from around the world. Stuart Sherman, Gary Stevens, Seiji Shimoda, Aaron Williamson, Hayley Newman, Station House Opera, Mark Jeffery (Goat Island) and Jeremy Deller all presented live work at the festival, whilst artists such as Christo, Gary Hill and Aleksandr Sokurov were represented by video works. CAT fulfilled an important role in the development of performance art in Wales, not so much because of its spectacular event character, but by providing a forum for the documentation and dissemination of contemporary performance art practice, a form of performative 'publication' in the shape of a festival. This function was further enhanced by Howell, who filmed much of the first festival as a contribution to his *Grey Suit: Video for Art & Literature*, a perform-ance art magazine distributed on videotape, which was intended as an innovative approach to the recording of live art practice and remains to this day the only publication originating in Wales solely devoted to performance art.

CAT also brought André Stitt to Cardiff, who presented three of his intensely visceral and cathartic 'akshuns' at the festival. The themes of the Belfast-born artist, issues of oppression, freedom, subversion, alienation from and appropriation of cultures, resonate strongly with the concerns of many political artists in Wales. Stitt took over from Howell as subject leader of the time based department in 1999, which he now runs in collaboration with Paul Granjon, a French artist

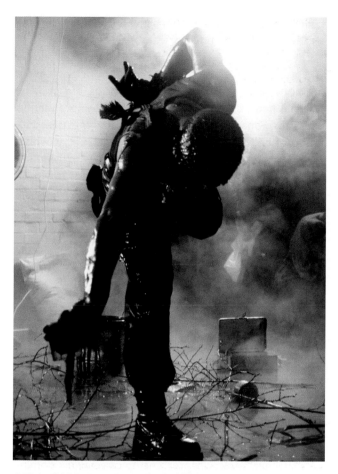

CAT: André Stitt, 'Learning to Fly', Cardiff Art in Time 1999.

working in robotics, whose playful performances and installations take a tongue-in-cheek look at the relationship between human and machine. Recent performance graduates from Howard Gardens include Kira O'Reilly, Robin Deacon, Eve Dent, Phil Babot, Richard Dedomenici, Paul Hurley and Matt Cook. Cook in particular creates works that directly reflect on their urban environment. His sound work, 'Pendulum Electronica', an extension of Steve Reich's famous Pendulum Music, featured swinging torches above light sensors that triggered a series of sound samples

collected from around Cardiff, which produced an increasingly dense aural portrait of the city.

On the other side of town from Howard Gardens is Chapter Arts Centre, Wales' most important centre for contemporary art. A former school, the building was opened as an arts centre in 1971 by local artists Christine Kinsey and Bryan Jones, with journalist Mik Flood. Their vision was to establish a place that would serve the local community as well as provide an environment in which all creative disciplines could be housed under one roof. More than thirty years on, Chapter has developed into an extensive complex of artists' studios, performance spaces, galleries, cinemas, and premises for various cultural enterprises. It now presents over a thousand events a year and works with partners from all over the world. It also still functions as a meeting place for community initiatives, mother and baby groups, the local Buddhist congregation and weekly Yoga classes, although the two sides to its activities rarely meet.

For a long time Howard Gardens in the east and Chapter in the west of the city presented the main two sites where performance practice in Cardiff was created, but between which there was surprisingly little exchange. Howard Gardens was devoted primarily to performance work that had its roots in the traditions of visual art, while Chapter championed work coming from experimental theatre, multimedia performance and new dance. This separation has changed in recent years – the two scenes today are much more interconnected. The reasons for this development are manifold: in the UK generally an increasing blurring of the boundaries between theatre and performance art has taken place, which manifests itself in the widespread use of the term 'live art' for practices emerging from both. In Wales specifically, a recent crisis in arts funding has led to the abolition of most of the ensembles and companies working in the experimental theatre sector. What has emerged in the wake of this crisis is a new generation of solo performers (Eddie Ladd, Simon Whitehead, Marc Rees), often working in highly conceptual ways, whose practice owes as much to the tradition of performance art as it does to that of theatre. Under its theatre programmer, James Tyson, Chapter has in the past few years organised a number of festivals (12 Days of Risk in 2000 and Experimentica annually since 2001) which have been devoted to the presentation and discussion of innovative time based work, including performance, video, sonic and installation art, and which have acted as great catalysts for the development of emerging artists working in this field in Wales.

By opening itself up to the support of young local artists practising time based art, Chapter has managed to reassert its position within the contemporary art scene in Cardiff. But in this it has been joined by an increasing number of artist-led venues devoted to innovative art, among them tactileBOSCH, Morefront and G39. One of the most performance-oriented of the new venues is tactileBOSCH, which is situated in a reclaimed Victorian laundry and opened as a studio complex and alternative exhibition space in 2000. In the mere four years of its existence, it has developed into one of the main players on the Cardiff arts scene, driven by the seemingly limitless creative and networking energies of its founders, Kim Fielding and Simon Mitchell. Fielding and Mitchell have built a reputation for establishing international exchanges between artists and galleries in a host of other countries, helping to bring a wide range of work into Wales for their 'ridiculously large international multi-media exhibitions', and in return raise the profile of Welsh art abroad. TactileBOSCH's 'carnivalesque' curatorial approach (described by local critic Debbie Savage as 'throw as many people into the mix as possible and see what happens') often favours performance work of a vaudeville nature that is able to withstand the legendary party atmosphere of its opening nights. Among the artists who regularly present work at the venue is Mitchell himself. His work is task-based,

including such actions as attempting to grab a pint of beer repeatedly whilst being pulled back by an elastic band. His performances confront clichés of macho masculinity from a very British perspective: whoever has found himself in a bar in Cardiff, the drinking capital of Britain, on a Friday night will recognise the images of aggression and violence with which Mitchell plays.

Increasingly, Cardiff itself becomes the focus of much of present-day performance work in the capital. Performance collective Pearson/Brookes is currently engaged in a series of works for the city, multi-site events for several groups of audiences watching different situations occurring simultaneously in different locations in the town, recorded by the spectators themselves and then assembled in a multimedia installation in Chapter's theatre space. Good Cop Bad Cop (Richard Morgan, John Rowley and Paul Jeff) created an event in which they tried to break the (often archaic and abstruse) by-laws of the city and document their transgressions with the help of camera-phones. Artist Jennie Savage, whose practice has a strong socially engaged approach, created

Pearson/Brookes, 'Carrying Lyn', Cardiff 2001, Photo: Paul Jeff

Anecdotal Cardiff in 2003, an archive of stories from and about Cardiff, which she collected whilst working as artist-in-residence at the town's central library. The archive was made available in the library's local history section and later staged as a guided bus tour, visiting many of the locations to which the stories referred. Cardiff Projects has undertaken a series of situationist dérives in and around Cardiff, among them a search for the Heart of Cardiff and Relax Cardiff, a psychogeographical survey of leisure in the city. And SWICA (South Wales Intercultural Community Arts) engages the city's multi-ethnic communities in celebratory street actions such as carnival and light processions. Performative civic explorations like these are not limited to the Welsh capital either: Locws International, a bi-annual series of site-specific installations and events located across the city of Swansea, was created as a response to the varied topography, history and architecture of Wales' second city.

Y Rhwydwaith – The Network

It is this isolation of everything not on the map that so potently naturalises what's on it. (Wood 1992, 87)

No map is complete without a consideration of that which remains unmapped, in this case the increasing number of artists' collectives and networks in Wales. The Artists' Project (one of the longest-established of the groups), the Umbrella Group, fourchette and Trailerpark are all artist-led collectives that organise collaborative exhibitions and performance events. Dempseys, an old Cardiff pub, has become the venue for a regular meeting of experimental music and sonic art, The Quarter. Other networks are devoted to discourse rather than display: Bloc is a virtual forum for art and technology, which organises seminars and conferences to raise the profile of digital media in

Wales. The 2nd Wednesday Group is a loose network of around a hundred artists, writers, teachers and students with an interest in performance, cross-disciplinary, live and time based art in Wales. It was founded in December 2001 as a forum for discussion, to share information and to develop advocacy in an area of artistic practice that in this country has notoriously lacked sustained critical attention and incisive theoretical reflection, a lack that has often hindered its development.

Some of this reflection is provided by *Performance Research*, a peer-reviewed academic journal that aims to promote innovative connections between scholar-ship and practice in the field of contemporary performance. Although published in England by Taylor and Francis and international in scope, the journal maintains close links with Wales through one of its editors, Richard Gough. Gough is Artistic Director of the Aberystwyth-based CPR Centre for Performance Research, at its roots a theatre organisation devoted to training and the reflection of practice, which organises workshops, festivals and symposia, publishes theatre books and runs a multi-cultural performance resource centre. The CPR's decidedly intercultural approach to theatrical performance has from very early on brought it into contact with the emerging academic discipline of Performance Studies, which it has helped to promote in Britain through a range of international conferences. The CPR assisted in establishing the Performance Studies network PSi Performance Studies international, a world-wide membership association for scholars and artists working in the field of performance, and co-hosted the 5th Performance Studies Conference in Aberystwyth in 1999, which brought several hundred artists and scholars to west Wales, among them Peggy Phelan, Richard Schechner, Rebecca Schneider and Guillermo Gomez-Peña, for an exploration of the rapidly shifting definitions at play within the field.

These networks may take temporal possession of a site, but otherwise remain largely virtual, nomadic and decentralised. Yet even the most 'sited' of the Welsh arts initiatives mentioned above find themselves engaged in a multitude of networks, acting locally as much as internationally, putting collaboration and exchange at the heart of their activities.

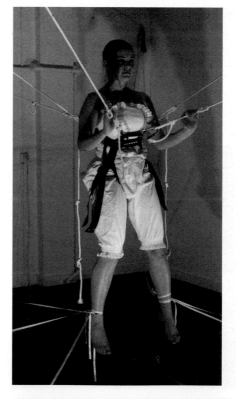

Kim Simons, Umbrella's 'Catalyst' event, Cardiff 2003,
Photo: Umbrella

Part Two
Y Tŷ – The House: Trace and the domesticity of art

House: Inside Out and Outside In

THRESHOLD 1: Inside Out

Eve Dent: "My Niche" (Season 1)

For those who stand in an empty living room, there is nothing to do but perform a polite and perplexed waiting. Nothing happens, the artist appears absent. After a time there comes a low thump, and a small black avalanche crumbles down into the empty fireplace. Intussuscepted by the house within its carbonised heart(h), she hovers, an unseen statue who silently points to something unknown within the landscape of human domesticity (Sigmund Freud).

The re-assurance of 'home' is palpably dwindling. She is folding space inward with her invisible being-there. She is, for us, a suspension, a sense of being, at the same 'incomprehensible' time, both dead and alive, neither dead nor alive. We are left in our comfortless waiting, broken only by an occasional colloquy of thumping and soot-falls, until we notice her blackened fingers. They have crawled slyly into the room, clinging like ivy, curled as if to lift the wall away. Then toes peep, a filthy leg, a body twisted in negotiating this threshold, until at last she emerges. Wearing a simple white dress and a disposable breathing-mask, her clothes and skin are stained with ashes. She appears as something other, alien. She is *das unheimliche*, that familiar stranger, becoming so by becoming visible. She comes as the return of the Real, where the Real is what cannot be rationally expressed, constructed or deconstructed. It is that old familiar thing – trauma: buried long and deep in the darkest hidden chambers of the heart.

(Sara Rees 2003)

'house': 'a building made for people to live in'

Performance can be a greedy art. However ephemeral, it must take place, even if only temporarily. In Wales, where dedicated art spaces are scarce, performance has, as we have seen, over the years taken possession of a number of different sites. Most of these have been places of work or worship – following the collapse of heavy industry, the crisis in agriculture and the demise of active faith, factories, farms and chapels have stood empty. And when economy and religion moves out, art moves in. Beyond a mere pragmatic supply of space, such moves have offered new aesthetic opportunities and curatorial possibilities. The resulting work has frequently engaged with the particular cultural and social histories of these places, resulting in complex negotiations between the properties of performance and place in truly 'site-specific' manner. But once art begins to make a lasting home in these spaces, their former occupation starts to disappear from view. It may even become an obstruction to their transform-ation into locations for art. Chapter Arts Centre in Cardiff was formerly a school and yet traces of its days as a teaching institution are increasingly difficult to find as the building is being continually converted and

renovated to provide suitable accommodation for the artists that work there. tactileBOSCH, a much younger venue, is slowly but surely changing the original outline of the old laundry in a fight against damp and cold. At the end of such conversions, what we are often left with are some quirky architectural features, but the presence of the historical and social architectures that the places once possessed has all but disappeared.

Trace is different in this respect. Not that its architecture offers much to work with. The room itself looks like you expect a gallery to look – clean, white walls, painted floors, a glass door. There are few traces left of the living room it once was. But the house around it is very manifestly still home to someone. Its functioning as an art space and its role as a domestic space are deeply interwoven, and it is this inter-penetration that creates a unique context for the performance work presented there. Performance art has, of course, a long history of using domestic spaces. The 'Happenings' of the late fifties and sixties were often situated in artists' lofts which stood for a fusion of work and life. Specially constructed environments were built from everyday materials, and the actions that were placed within them celebrated the ordinary and quotidian as material for art. Later on, making art in their homes allowed artists as diverse as Bobby Baker and Tehching Hsieh to question the sanctioned locations of studio or gallery where art may rightfully be produced and consumed, or to interrogate the value of the artist's work in a capitalist economy that increasingly impinges on the realm of the private. Trace and its domestic setting too asks us to consider the economy that governs art making and presenting. But it does so in a different manner. Trace is decidedly both home and gallery, private residence and public art space. The quality of the work presented, the regularity of the monthly programme, the standard of publicity and publications all deliberately mark it as a fully professional, institutionalised gallery, which for a few years now has also received a small amount of public

funding. On the other hand, the attitude toward inviting and housing artists and welcoming the audience is infused and sustained by the principles of hospitality, generosity and mutual exchange, principles that are part of a different economic order. But this order is no longer romantically idealised as a refuge from the capitalist dictates of the art market, and the private does not appear as the more authentic. Instead, Trace seems to be fuelled by the vision that it is in the in-between of these realms that a different way of making and engaging with art may be achieved.

Artists have responded to Trace's distinct in-between nature as house/gallery in a variety of ways. The manner of their responses has not been 'site-specific' in the usual sense and yet has been true to the spirit of the place. They have all proposed different reflections on how art can be housed. Two works stand out in particular. Cardiff-based artist Eve Dent's beautiful performance in the flue of the chimney explored what, following Derrida, we may call the 'spectrality' of the house itself. This spectral nature manifests itself in the traces, the remnants of a certain past that haunts any site. Dent, however, did not embody a specific memory. Rather, she gave expression to the house's capacity and effort to remember. In an insightful response to her performance work, fellow artist Sara Rees emphasises the liminal nature of Dent's practice: placing her body into the very fabric of the building itself, she exists on and passes through many thresholds – between inside and outside, sensuality and horror, and between house (as site) and art (as work). Roddy Hunter's work for Trace too passed across a variety of thresholds. His carefully composed performance, '[The Noise of] The Street Enters The House; [The Noise of] the House Enters The Street' explored the effects of urbanism upon domestic and public space. His was one of few works that took actual account of the location of Trace in an area of social deprivation. The performance investigated the porosity of social space and the conflicts and opportunities it engenders. It asked how

the narratives of social realities may enter into a work of art, and how the utopian potential of art may enter into the fabric of urban life. And it proposed that the site at which such a reciprocal entering into may be attempted is the in-between place of the house/gallery.

THRESHOLD 2: Outside In

Roddy Hunter: "[The Noise of] The Street Enters The House

[The Noise of] The House Enters The Street" (Season 4)

Here's how it happened about 6.00pm on 10th January. In the room was a mattress lying next to a radiator. There was a dead bird I'd rescued from the gutter outside 26 Moira Place the day before. There was also a light box on a table facing the other wall. Oh, I forgot that there was also an old, mangy, pink, presumably woman's coat, lying on the mattress too. The coat, and the mattress like the bird had been salvaged from the street a couple of days before after a heavy downpour of rain. I found these in the streets surrounding Moira Place.

So, here's what happened. I rolled up the blinds and opened the windows to let the sound from the inside meet the noise from the outside. I'd waited from the room to go quiet. I rolled the blinds back down so we'd think more about aural rather than visual concerns and because I was probably going to take my clothes off later. Oh, yeah, and we wanted the room to be cold, really cold, but an industrial air conditioner cost £180 per day and we couldn't afford

it... In the end, I open the windows, chalk a crack from the window across the floor, sit at the light box, look at slides, wear elastoplast, take temperature, go to mattress, take the temperature of the bird, wear elastoplast on my eyes, so I can't see, undress/dress in old coat, ask for hammer and masonry chisel, make a new crack across the floor with a hammer and masonry chisel, return/dress, take thermometer, place on light box, look at slides, chalk line on crack and close the windows. 'Why can't we live together'.

(Roddy Hunter)

Public: Watch, Witness, Surveillance

WATCHING 1: Witness

Kira O'Reilly: "close/d" (Season 1)

She is sitting on a chair, left leg propped against the white wall in front of her, back turned toward us. The leg is covered in surgical tape, fixed in long, thin strips from foot to groin and round the calf and thigh, forming a neat grid of small squares within which the flesh is bulging. In her hand a surgical knife, she is making precise incisions into these rectangles of skin, always cutting diagonally from top left to bottom right. Droplets of blood appear until the leg is covered in dozens of thin red streams. Like the slash that breaks apart the performance's title, her every cut slits open the skin's close membrane, placing a wound at the threshold between her body's inside and outside.

Next to her stands an empty chair. An open invitation to sit with her, watch her, be a witness to

her act. The intimacy of this arrangement concentrates our attention onto the very moment in which the knife penetrates the soft tissue of the flesh. Yet, up close, I feel no discomfort, nor do I feel the need to comfort her. With every penetration of her flesh, done so precisely and matter-of-factly, she seems to assert her power over her body, her power over her art. Like the slash that breaks apart the performance's title, her every cut seemingly undoes and yet in truth affirms the distance between us. She moves us from a sense of being close, to the realisation that her experience must to us ultimately remain closed.

'public': 'made, done, or happening openly, for all to see'

It has become a common trope in performance theory to refer to the audience's role in a performance event as to that of a witness. To witness a performance here implies to be present at it in an ethical manner, to share a sense of mutual responsibility for the act one observes. It is easy to see why the notion has found such a wide acceptance – it endows live performance with an inherent ethical politics as it allows us, as theorist Peggy Phelan has proposed, to conceive of it

> as a way to rehearse our obligation to the scenes we witness in realms usually labelled [sic] the representational or the mediated. (Phelan 1999: 10)

Compared to the disembodied realms of the representational or the mediated, live performance appears tied to an ethical stance by human bodies forced to see each other eye to eye. But the term of the witness resonates with histories and associations that make it as problematic a concept as it is seductive.

The act of witnessing is not complete without the act of 'bearing' witness – the overtones of sufferance and endurance that this phrase carries with it are not coincidental. The witness, as philosopher Giorgio Agamben (1999) reminds us, is a person who has lived through something, a survivor. Its equation with the audience at a performance event runs the risk of elevating what can at times be quite a trivial relationship, that of the watcher to the watched, and turn it into something rather more profound. But perhaps more problematically, it tends to reduce what is a complex relationship to just one dimension, to that of the compassionate accomplice. What about boredom, inattentiveness, suspicion, confrontation, aggression, distance or even those moments when the performance reaches over and implicates the watchers in a way that challenges their status as bystanders?

Trace demands that artists investigate the different facets of this relationship by the very nature of the space itself. This is a private house, and we, the audience, are first and foremost guests here. Artist Julie Bacon, who came to Trace's opening performance by Alastair MacLennan in 2000, describes the impact the venue's domestic situation has on its visitors:

> The large group of people that had come along were mostly bustling in the kitchen (like at the best of parties), having a cup of tea, juice and crisps ... The situation did not suffer pretension, as the domestic setting seemed to make for a diminished sense of territory and heightened sense of responsibility. By this I mean that the occasional sophistry of art audiences which allows a kind of blasé knowing before the event, was unsettled, – the behavioural codes are mixed. I felt a recognition of a shared context and overlapping reality, which many current art projects aspire to; this is more than a matter of delivering opinion; in the intimate realm of another one senses one's own gestures and accordingly responsibility. It is this presence that underlies Trace...

> (Bacon 2001: without page number)

It is this implicit presence, a sense of responsibility prompted by the private nature of the space which makes us all intruders by invitation, that allows artists to investigate the audience's attitudes in all their possible manifestations.

Kira O'Reilly's action addressed us most obviously in our role as witnesses. Similarly, and no less compellingly, we were made aware of our own presence/present and its potential impact when dropping in on the contemplative durational pieces of Kevin Henderson or Eve Dent. John G. Boehme, on the other hand, literally drove out the audience from the room by hitting hundreds of golf balls against the wall. We found ourselves hiding from the bouncing balls behind the doors of the gallery entrance, peeking in. We have also looked for shelter from Istvan Kantor's filing cabinets and tried to avoid the splashing paint and splintering wood that Sinéad and Hugh O'Donnell hurled at each other in their powerfully aggressive exploration of siblinghood. And we have followed Brian Connolly's invitation to play competitive board games and Hiromi Shirai's request to blow up plastic gloves to help her make inflatable cushions. The latter explored what we may call, with a currently fashionable term, a 'relational aesthetics', turning us watchers into a temporary community of active interlocutors. Indeed, many of the artists who presented at Trace used small relational gestures with which they drew us into their pieces – Amanda Heng served cups of tea and Jerzy Beres shots of Polish vodka, Valentin Torrens handed out Russian lottery tickets and Myriam Laplante gave us furry mice in chocolate coating. The thrill of such moments derives from the potential for something unpredictable. At one point in James Partaik's performance, a highly controlled piece which investigated the act of watching as one of surveillance, the artist handed a tape machine to a member of the audience whilst enveloping himself in the magnetic tape – a gesture which prompted Partaik to quite literally lose control, spinning and stumbling, knocking over a bowl filled with ink, spilling the black fluid all over the floor.

It is from these moments of unpredictability, when the artist relinquishes control over the work to the audience and the work itself threatens to spill out of its own framing and take on unexpected meaning, that Claudine Cotton fashions her performance practice. Cotton's action was, like that of Partaik, part of the Rhwnt Wales-Québec performance exchange that Trace initiated with Québec-based gallery, Le Lieu. Cotton herself prefers the term 'manoeuvre', which relocates the interactive ethos of relational aesthetics to non-art contexts, where it engages with a largely accidental and unsuspecting audience. Consequently, she was the only artist in Trace's five-year programme who worked outside the gallery (with the exception of her Canadian colleagues who presented work at Chapter Arts Centre, a dedicated art space). In Cardiff, Cotton chose the most British of locales, the male-dominated environment of the pub, into which she brought an action that is traditionally associated with femininity: that of knitting. Cotton had prepared woollen blue berets, which she slowly unravelled to make small baby shoes from its wool. She involved the afternoon drinkers by letting them wear the hats or let the wool pass through their fingers. The literal conversion from blue beret, an obvious reference to the UN peace-keeping force, to baby shoes suggested in its metaphorical nature other occasions of change: from head to foot, from thought to action, from present to future generation. As with many relational works, the question arose whether the interpersonal 'warmth' the performance provided did not in fact distract from its political-utopian content. But it was a joy to see how during the course of the day, the mainly middle-aged men changed their mood from initial hostility and ridicule to a hesitant form of engagement, slowly opening up to talk about personal reminiscences of their mothers and grandmothers knitting at home. Cotton's performance did not position the spectators as witnesses to its acts, but rather used its acts to solicit from them testimonies of a life elsewhere.

WATCHING 2: Surveillance

James Partaik: "America's Most Wanted" (Season 4)

Paranoia counts among the major pathologies of modernity, helping the modern state to legitimise the expansion of surveillance and control. Partaik investigates its workings in a rich and complex performance, which ultimately targets America's rampant culture of suspicion, yet which begins with the intimacy of a family story. A series of actions is structured around a recorded interview with the artist's aunt and her daughter, describing what they consider as their plight – their life on the run from an unspecified threat, stories of electricity that may harm them, of someone listening in and observing. It is strangely moving to hear their futile desire to make the indifferent world with which they are confronted the result of someone's intention, no matter how malevolent.

Partaik not merely comments on modes of surveillance, but actually performs them, opening up the creative act of making performance itself to reveal what is invisible or potential within it. At one moment he takes a tape machine, loosens the tape and moves the machine along it, carefully adjusting his speed so that the voices of the two women emerge. I am reminded of the techniques of professional stakeouts as well as our struggle for comprehension. His installation replicates this: the space is buzzing with the invisible power of electricity. One has to move, lean in, contort one's body to activate a system of triggers that plays extracts from the women's interview. Here we are observing, listening, keeping under surveillance, connecting, interpreting –

prompting us to consider how in art itself we desire to look for order, to make sense.

Traces – Between Ephemera and Remains

REMNANT 1: Ephemera

Julie Andrée T: "Unexpected Thought" (Season 2)

B1. BOOTS
a pair,
black, heavy.

B2. A BUCKET
shiny metal,
filled with water,
within it a pink facecloth.

C1. A CARPET
beige,
laid out along the full length of the room, taped to the wall at one end,
covered in smeared bright red foot prints.

C2. A CHAIR
black,
a kitchen chair,
plastic.

C3. CLOTHING
a white shirt, a pair of black trousers.

H1. A HOT WATER BOTTLE
bright blue.

M1. A MIRROR
small,
golden frame,
hung on the wall.

P1. PAINT
red,
in two plastic bottles.

P2. A PEN
red.

P3. PLASTERS or BAND AIDS
remains of in a small heap on the floor.

P4. POLAROIDS
twenty-five arranged in a row,
showing faces,
names and numbered identities.

S1. SHOEPOLISH
black.

S2. STAMPS AND INK
wooden blocks,
raised lettering,
black ink pad.

S3. A STRING
fixed in between the end walls,
strung along the full length of the room.

W1. WALL
tracings of body parts, mainly heads and legs,
outlined with black or red pen,
the drawing of a penis and a vagina.

W1. WALLPAPER
old fashioned pattern of copper vessels and fruit-baskets,
covering one wall and part of the floor,
covered in black shoe-polish.

W.2 WRITING
a list of actions scribbled in coal on the wall.

INSTRUCTIONS, task work, everyday or poetic actions constructed around a series of objects; repeated ritually; the unexpected thought that arises from the pre-determined but unpredictable.
OBJECTS, real, but lacking the identity with which traces of the past would endow them, mundane and banal; removed by the actions from the certitude of their everyday function.
IDENTITIES chosen, stamped on the forehead, tried out, washed off; making footsteps, tracing the body, dressing and undressing, exposing oneself, putting oneself on the line; the division between the identities of body and object challenged in action ('Be a Chair'). The imperative of identity is dissolved into a series of acts, with no chance of it returning to 'order'. Performance as ENTROPY, as the creation of an energy that is chaotic and unsettling.

'trace': 'a sign that remains to show the former presence of a person or thing no longer there'

Performance is commonly regarded as that which cannot be archived — its ephemeral nature at odds with the archive's quest for permanence, its disappearing acts resisting the desire to label, stack and store. And yet no other art form is thus occupied with its remains and their survival. The photos, videos, notebooks, drawings and objects it leaves behind have become the stuff of

heike roms 33>>

numerous collections, exhibitions and art books like the present one. Their status is ambivalent: they may be taken as material evidence for the transient actions and interventions with which they are connected or become elevated to artworks in their own right. But is this not a paradox? How can an art form which claims to derive its aesthetic and political impact from its temporal and temporary nature at the same time value its remnants in this manner? Does this not present a return to the commodification of the art object which performance art set out to critique? Performance art's ongoing fascination with its own materiality is only paradoxical, however, if one adopts the rather simplified oppositional stance of the 1960s and 1970s. Rather than regard ephemerality and materiality, presence and absence, action and remnant as being fundamentally different, we may instead, as performance scholar and queer theorist José Muñoz (1996) has suggested, consider ephemeral acts too as having material dimensions, without necessarily being 'solid' – and, we may add, regard materiality as possessing an inherently ephemeral dimension, without necessarily having to 'disappear'. It may be a political imperative therefore to ensure that performance remains, that it leaves a trace, that its transient energy can be recuperated. This is of particular importance for a minority culture like the Welsh one, where performance often finds itself made twice 'disappeared'.

Trace challenges artists to investigate this contested area by inviting them to develop 'a live investigation with the 'trace' elements of this activity exhibited as installation' (Trace publicity leaflet). The choice of the gallery's name is here programmatic – traces exist in the ambiguous space between materiality and immateriality, presence and absence. The implications of this ambiguity have been emphasised by Roddy Hunter in the catalogue for Trace's first season:

> Within absence there may be a material counterpoint to presence. It is through trace and memory than we find absence revealed, and both of these are core properties of experience and, though partially intangible, possess strong assurances of ontological security in existence.

The artists who have presented their work at Trace have responded to this invitation in different ways. Most of them literally closed the door on the remnants of their actions at the moment at which they ended their performance, leaving the leftovers to hover provocatively between significant memento and redundant waste. A small number restaged the leftovers as meaningful documents. But all of them proposed a complex investigation into the different ways in which performances remain.

Stuart Brisley gave an illustrated lecture on his 'Shit Archive', a collection of turds of all shapes, sizes and colours, suggesting that the boundary that our culture draws between valued object and trash, archives and rubbish dumps, is fluid and can be transgressed by objects in both directions. The 'shit archive' acknowledged the inevitable ephemerality of materiality by defining the value of an object as value-in-time. There were a number of other performances, most notably the works of Roddy Hunter and Julie Andrée T, which similarly staged the archive as event. In Hunter's case, the found objects around which his performance was constructed contained the visible traces of someone else's past actions. These traces connected us to the presence of others, of whom nonetheless we could have no certain knowledge. Performances by Jessica Buege, Julie Bacon, Kevin Henderson or Boris Nieslony too examined the nature of individual and collective acts of remembrance and the way in which these acts attach themselves to objects, texts and images. In a very different manner, John G. Boehme explored the relation of action, object and trace by driving 600 golf balls into an aluminium sheet hung on one wall of the gallery, thereby creating an object that incorporated the traces of his action as negativity in form of a series of indentations. And Eve Dent's performance was made visible only in the traces it produced, that is the soot

building up at the bottom of the chimney breast. The remnants of other performances were sometimes incorporated into the very fabric of the building itself, thereby undermining its assumed solidity: Brian Connolly had the floor of the gallery excavated to bury a time capsule within it. And Kira O'Reilly's action, in its self-conscious attempt to cut through the solidity of the body's surface, made her own skin into a palimpsest of scars, among which traces of former wounds, older performances, barely healed over, were still visible. Her body was thereby transformed into an archive which documented not just her own past performance work, but which linked us to a history of performance art as it is inscribed in the bodies of female artists such as Abramovic and Pane.

To those of us who pay a monthly visit to Trace, the performances we have seen there remain, but they remain not necessarily in the form of physical traces. This is not to say that some of them do not continue to exist in such a form: there is the perfect circle that Morgan O'Hara drew on the back wall by swirling her arm around her body; there is the time capsule that Brian Connolly filled with the remnants of his audience's actions and buried in the floor – the one since painted over, the other now concreted over, but both still there, gently mocking the concept of the 'white cube' gallery as a neutral space with no particular past. But more importantly, their actions have left traces in our memory which are no less material. Each performance resonates with those that have been and those that are yet to come: the line that Julie Andrée T. strung between the side walls pre-echoed a similar line in Zbigniew Warpechowski's performance. Two artists of different nationalities, genders, generations, aesthetics and politics become part of the same archive, a temporal and temporary archive of performance that is being created as a series of performative explorations of the same limited space.

REMNANT 2: Remains

Brian Connolly: "Initiate" (Season 2)

You know the game: What would the archaeologists of the future make of the content of the time capsule that Brian Connolly filled with the traces of his performance and buried beneath the floor of 26 Moira Place on the 2nd March, 2002? What meaning would they ascribe to the collection of game pieces, broken pottery, deflated balloons and decomposed party food? What would they deduct from these objects about the people who left them, their pursuits, their diet, their culture? What strange ritual would they assume went on here?

Would they be able to tell from these remains the arrangement of the room, with its big games table at the back and the smaller tables at the front, each of which was devoted to a different skill – pot assemblage, watercolour painting, magic tricks? Would they be able to speculate on the nature of the activities that went on at the big table, the playing of board games and the building of plastic aeroplanes? Would they be able to reconstruct the atmosphere of fun and playfulness, the chatter and laughter, fuelled by bottles of beer and bowls of finger food? Would they be able to detect the allusions to our globalised economy that underlie the competitive nature of the board games with their capitalist and war strategy themes? Would they know of the thickness of the air, the smell of sweaty bodies under hot light bulbs, the repeated loud bangs of someone hacking a hole in the floor with a hammer and chisel? Would they be able to make out Brian among the players, the initiator in his black dinner suit, part croupier, part

watchdog? Would they interpret the very assemblage of the objects in their container under the floor as a comment on the effects of our actions, on the nature of how performance remains?

and eventually destroying, the tribal cultures of America's indigenous peoples. Durham, artist and activist, reminds us that a house is never just one's home, but always already a public building.

Postscript: Un-housed

ANNEX: The other side of domesticity

Jimmie Durham: "Under Construction" (Season 4)

He is hard at work. Sawing, hammering, driving nails into the wood. Sweat is running down his face in small streams. He is building a house. A plain, fragile construction from slim wooden planks. A man making himself a house with his own hands – an action that in its simplicity seems both natural and elemental. And yet, with every blow of the hammer he lets off a heart-rending scream, with every movement of the saw he calls out as if in pain. This house is built on anguish and grief. He surrounds it with barbed wire, leaving no doubt where this house is located: 'You are now in Mexico' he says to the people on the other side of the wire, 'if you cross the border you'll get shot'. The house that Jimmie built is a nation made from and sustained by the pain of others.

Durham finally covers the wooden planks with photocopied texts taken from the diaries and pamphlets of white 'pioneers', from George Washington and Benjamin Franklin to Davy Crockett and Walt Whitman. They all speak of the necessity to instil in the 'Indian' a desire for home and individual property as a means of 'civilising', that is colonising

LITERATURE CITED

Agamben, Giorgio (1999) *Remnants of Auschwitz: The Witness and the Archive*, transl. Daniel Heller-Roazen, Cambridge, Mass. / London: Zone Books.

Bacon, Julie (2001) 'trace: the domestics of art' (Les zones hétérogènes de l'art), transl. Julie Bacon, in trace: (ed.), trace: installation art space – Season 1: Document 1; unpublished document, Cardiff; first published in French in *Esse Arts + Opinions 42* ('Practique Urbaines'), pp.62–68.

Bala, Iwan (1999) *Certain Welsh Artists: Custodial Aesthetics in Contemporary Welsh Art*, Bridgend: Seren.

Bala, Iwan (2003) *Here + Now: Essays on contemporary art in Wales*, Bridgend: Seren.

Foucault, Michel (1986) 'Of Other Spaces', *Diacritics 16*, 1: 22–7.

Muñoz, José Esteban (1996) 'Ephemera as Evidence: Introductory Notes to Queer Acts', *Women and Performance 8*, 2: 5–16.

Phelan, Peggy (1999) 'Performing Questions, Producing Witnesses', in Tim Etchells, *Certain Fragments*, London: Routledge, pp. 9–14.

Rees, Sara (2003) 'Threshold – on the work of Eve Dent', *Platfform – Contemporary Performance Practice in Wales 1*: pp.24–29.

Sager, Peter (1991) *Wales*, London: Pallas Guides.

Wood, Denis (with John Fels) (1992) *The Power of Maps*, N.Y.: Guildford Press, 1992.

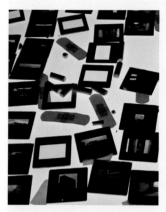

Eve Dent

Roddy Hunter

Kira O'Reilly

James Partaik

Julie Andrée T.

Brian Connolly

Jimmie Durham

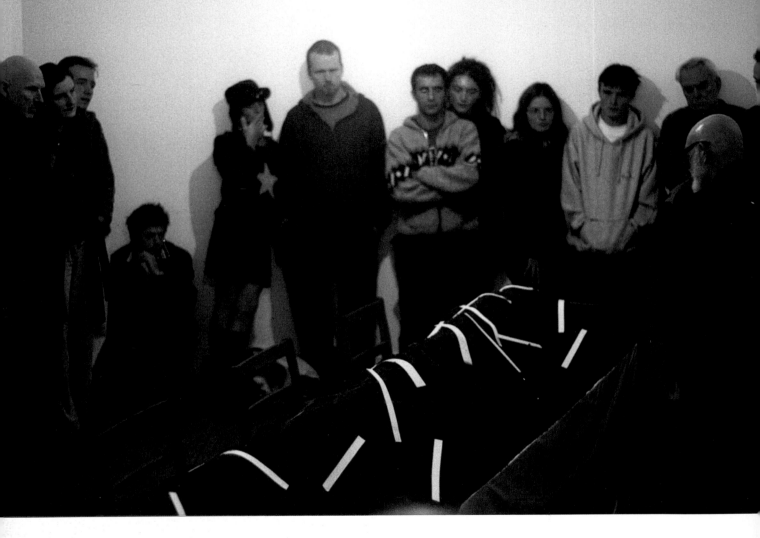

<<**Alastair MacLennan** [N. Ireland]

"Stolons" [II]

performance/actuation
17:00–18:00
7th October 2000

Stolon: reclined or prostrate branch that strikes new root. And develops new plant.

Born in Scotland in 1943 and based in Belfast since 1975, MacLennan's work has traversed the territories of performance and interdisciplinary concerns in a highly evolved political, poetic and compassionate engagement with contemporary issues.

MacLennan is a professor of Fine Art at the University of Ulster in Belfast and a member of Black Market International. His work has been presented throughout the world and has recently represented Ireland at the Venice Biennale in 1999.

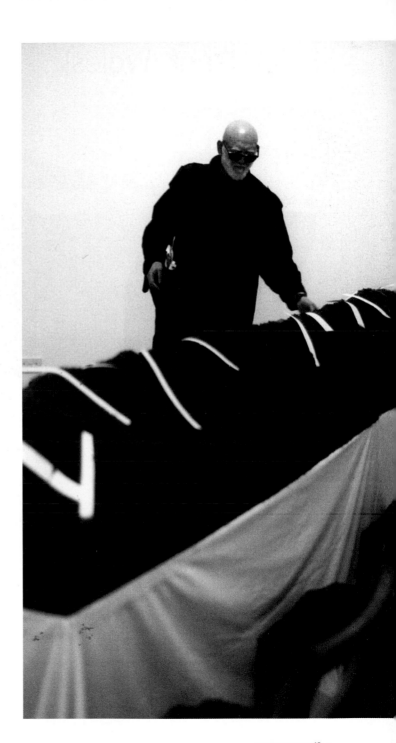

<<**Eve Dent** [Wales]

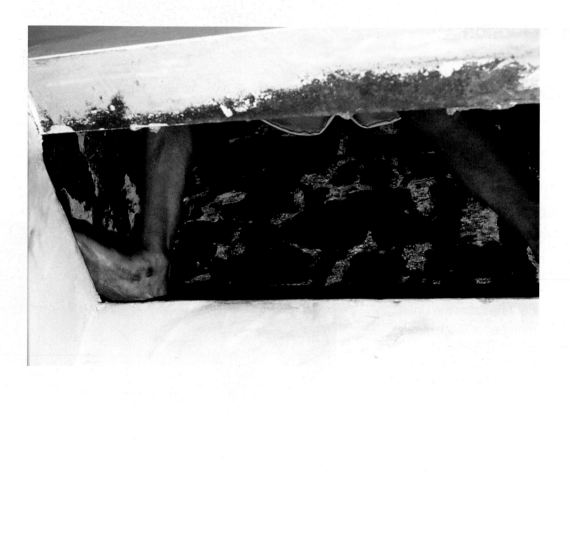

"My Niche"

performance 16:00–18:00
4th November 2000
installaction exhibition
5th–19th November 2000

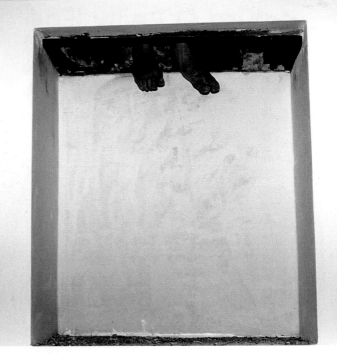

Like Dent's previous work, "My Niche" is an exploration of absence and presence. The artist responds to the space by creating an interplay between hiding and being seen, mimicry and merging the body with the environment.

Based in Cardiff, Eve Dent has been producing work in the UK and Europe since graduating from Cardiff School of Art in 1999. Recent work includes Expo in Nottingham, Transeuropa in Germany and the Site Gallery in Sheffield. In 2005 she presented work in the prestigious live art event Navigate in Newcastle-Upon-Tyne .

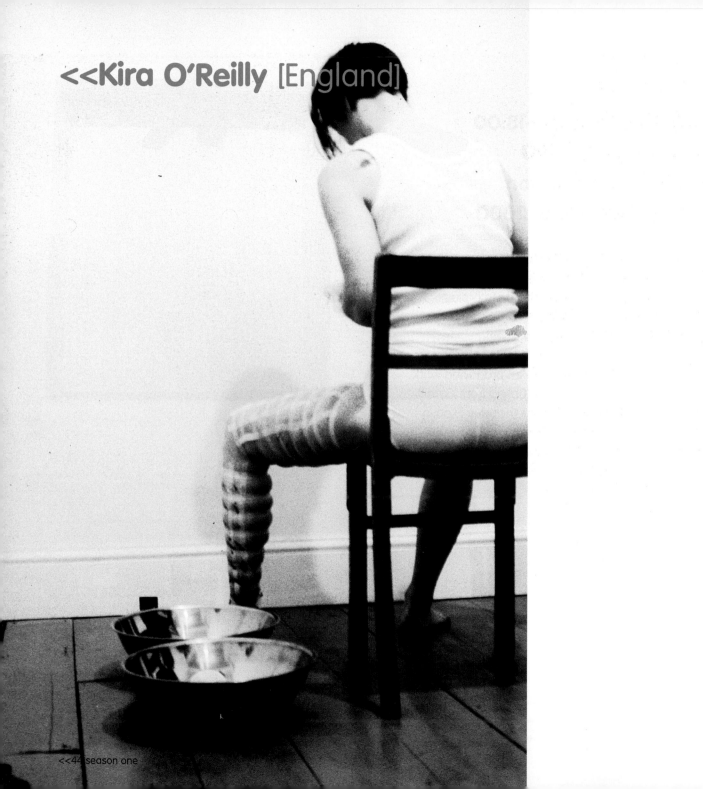

<<Kira O'Reilly [England]

"Close/d"

**performance 17:00–18:00
2nd December 2000
installaction exhibition
3rd–17th December 2000**

Kira O'Reilly employs performance to consider the gendered body as a site in which narratives of the personal, sexual, social and political knot and unknot in shifting permutations. Direct interventions into the materiality or fabric of the body explore relationships between interior/exterior spaces and the 'impenetrable' container of a coherent fixed 'self'.

O'Reilly graduated from Cardiff School of Art in 1998. Since then she has performed throughout the UK, Europe, and Australia. She has received a number of major commissions and was invited to produce work for Span2 international performance art residency in London, 2001.

<<Jamie McMurry [USA]

"Fever Pitch"

performance 18:00
13th January 2001
installaction exhibition
14th–28th January 2001

Jamie McMurry has been presenting original performance works throughout North America and Europe since 1990. He is also a lecturer in performance at SMFA, Boston.

McMurry states the following about his work at Trace: "The immediacy of the activity – the compulsion that states without statement – the range and power of the action – performance reluctantly declares itself alone by choice and proudly declares itself family, unintentionally."

[1] timed actions begin, each one becomes progressively longer than its predecessor and then shorter.

[2] we are surrounded by traces and our bodies are covered in remnants

[3] our deteriorating world tells of a history, our scars tell of personal triumphs and tragedies

[4] the battle to overcome those pasts and control the unknown road ahead

[5] CREATING TRACES FOR A FUTURE THAT HAS YET TO EXIST

<<Lee Hassall [England]

"Like a budgie with two mirrors"

**performance 15:00–18.30
3rd February 2001
installaction exhibition
4th–18th February 2001**

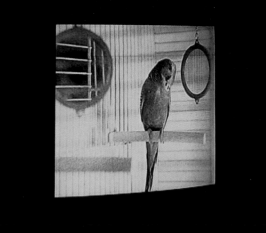

This piece of paranoia combines live introductory action with 16mm film footage transferred to video using single frame function, making each frame a self portrait. An eye appears in the cage bird's mirror. The single frame footage strangely animates both budgie and eye. A tape plays wild birdsong.

"In the last few years I have been using silent film as a sculptural tool to explore differing types of inhabited space. Using film is a way of focusing on objects and subjects offering them an extended eye. The films show people involved in habitual/mundane activities. These portrayals become strangely stimulating. Tiny details, because of the absence of larger events, acquire unexpected importance and drama."

Lee Hassall is a graduate of the Slade School of Art [1998] and completed an MA at Chelsea School of Art in 1999. He has recently completed a major commissioned work along the Sustrans National Cycle Network and presented installation work at Fordham and Annely Juda Fine Art, London. He is currently a lecturer at Hereford College of Art.

<<Jessica Buege [USA]

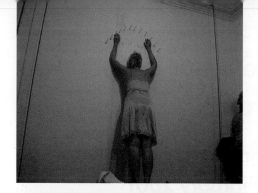

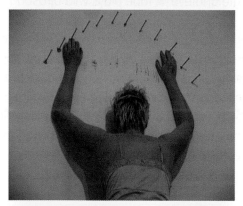

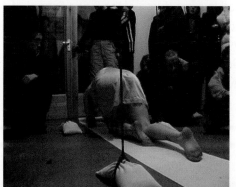

"Trash"

**performance 18:00–19:00
3rd March 2001
installaction exhibition
4th–18th March 2001**

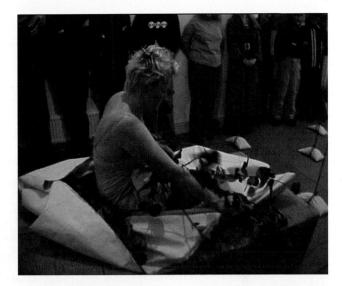

Jessica Buege's performance/installations have been widely exhibited in the United States and Europe. Based in Los Angeles and New York, Buege uses her body to negotiate objective territory utilising the concept of labour and the vocabulary of bondage/ escape to create ritual actions or mortifications.

In "Trash" Buege investigated the idea of the monument, using monument as tomb, historic marker and as metaphor for structures of belief which resist change. In addition, Buege weaves in "trash" images of insufficient connection and suture, expressing the pathetic melancholy related to loss and death.

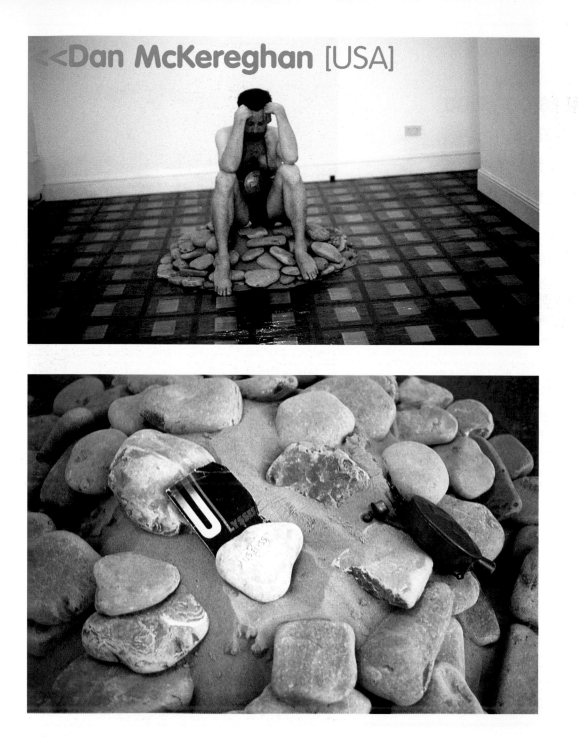

"At sea"

performance 15:00–18:00
31st March 2001
installaction exhibition
1st–15th April 2001

"At sea" is a meditation on the themes of wandering, discovery and isolation.

Dan McKereghan has been producing performance artworks for over 30 years. He is based in New York City, where he has presented almost 100 performances and street actions. Recent solo works include presentations at prestigious festivals including Annart in Romania, Castle of the Imagination in Poland, Cleveland Performance Art Festival, USA and Amorph! in Helsinki.

Since 2002 he has been curating Currency, New York's only regular major performance art festival.

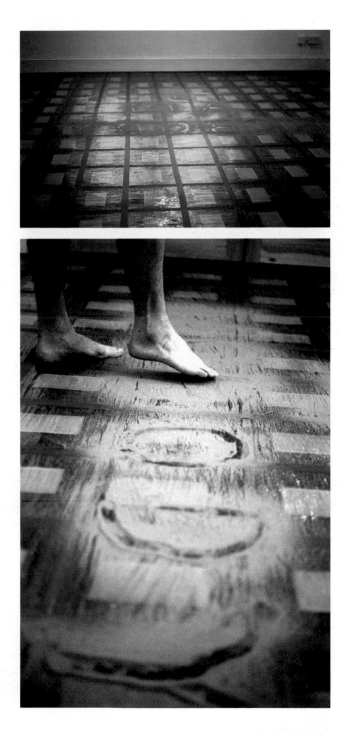

<<**John G. Boehme** [Canada]

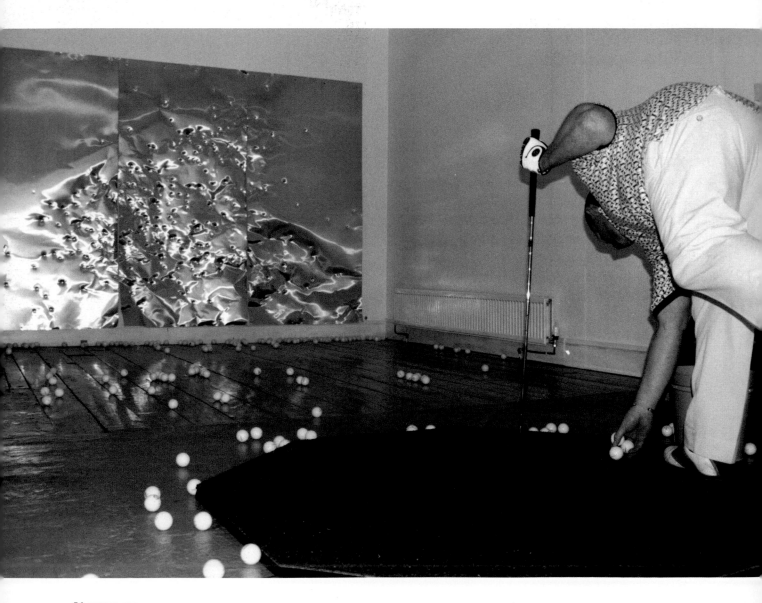

"Fore mien"

performance 15:00–18.30
5th May 2001
installaction exhibition
6th–21st May 2001

Boehme's durational work continues his fascination and investigation of men and their leisure pursuits. Over a period of three and a half hours the artist drives 600 golf balls into an aluminium clad wall of the gallery.

Boehme's work is a co-mingling of conceptual considerations with pure aestheticism. The viewer is drawn to the visual seductiveness of the piece, and through this sustained interaction, the conceptual aspects are revealed. This disclosure is often a simple statement of fact or of humour which presents itself without anger or defensiveness.

Boehme gained his inter-media degree at Emily Carr Institute of Art, Vancouver and has recently been awarded an MA at the University of Victoria BC. He has produced installation exhibitions throughout Canada, the USA and Europe. His recent work includes residencies at Banff, Canada and CAMAC Art Centre, France. He also curates performance art events in Victoria and Vancouver and represents an emerging generation of performance artists from the northwest Pacific rim.

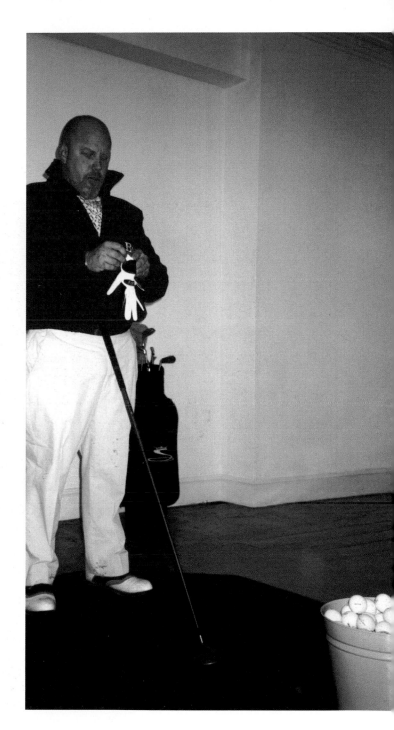

02

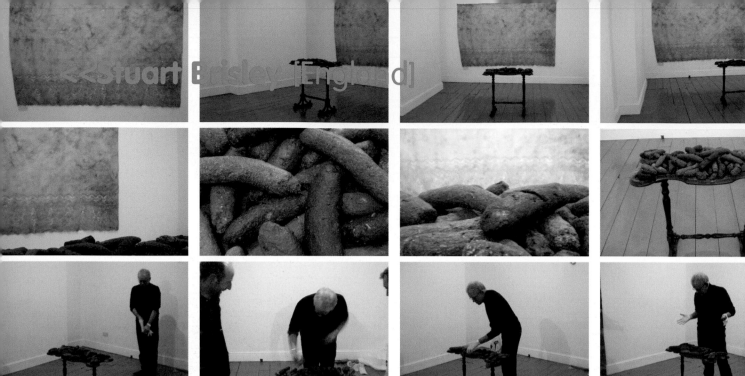

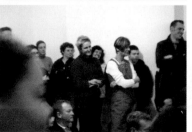

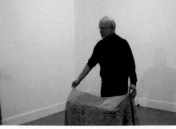

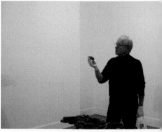

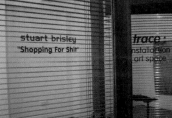

stuart brisley
"Shopping For Shit"

trace:
installation
art space

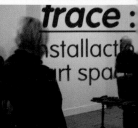

trace :
installaction
art spac

"Shopping for shit"

**performance 18:00
12th January 2002
installation exhibition
19th/20th & 26th/27th January
2002**

Brisley's seminal art practice has, for thirty-five years, greatly informed the development of performance art in the UK and Europe. His cultural renown and notoriety stems largely from his experiments of the sixties and seventies, which physically challenged the body's points of psychological, material and emotional resistance and flow. His work inquires into relationships between volition and compulsion that exist regardless of the veneer society projects upon birth, death, sexuality and politics.

He was Professor of Media Fine Art Graduate Studies at the Slade School of Fine Art, has exhibited his work globally, and is recognised as one of England's most decisive contributors to the late-twentieth-century avant-garde in visual art.

At Trace he presented work from his on-going project Ordure/Abfell [Ordure, dirt: anything unclean; Abfell (German): scrap, remnant, waste], which investigates the notion of what constitutes rubbish.

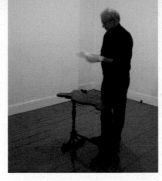
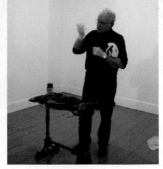

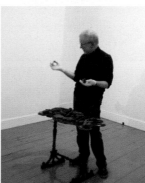
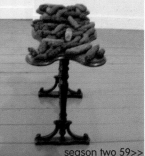

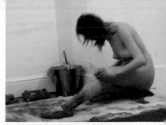
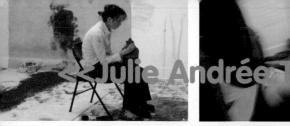

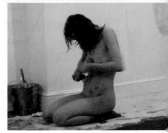

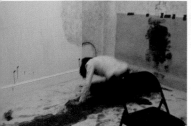

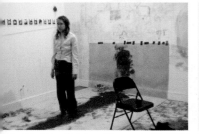
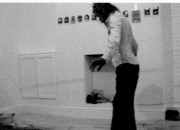

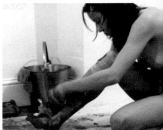

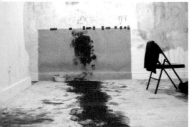

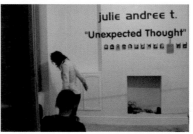
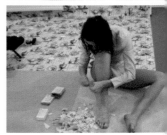

julie andree t.
"Unexpected Thought"

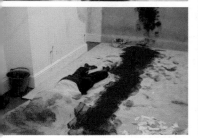
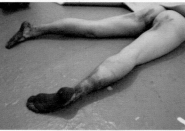
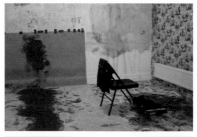
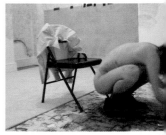

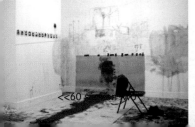
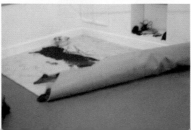

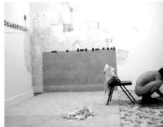

"Unexpected thought"

performance 18:00
2nd February 2002
installation exhibition
3rd–24th February 2002

"..when actions such as walking, talking and making sound are performed within a context where a clear imprint of action is left within a space in which it was produced, one can see a real cohesive relationship between action and matter. As if the echoing of human gesture possesses a valuable and sensitive continuum, even within the smallest of traces."

Julie Andrée T. represents a new generation of emerging artists from Québec who were invited by Trace as part of a Wales-Québec exchange project. The project, entitled RHWNT, developed and produced work during 2002-2004 in partnership with Le Lieu, Centre en Art Actuel.

Since the early 1990s Julie Andrée T. has been actively engaged in performance art actions and events including intervention and dance related projects in Montreal and Europe. She travels extensively, producing work at galleries, festivals, projects and events throughout the world.

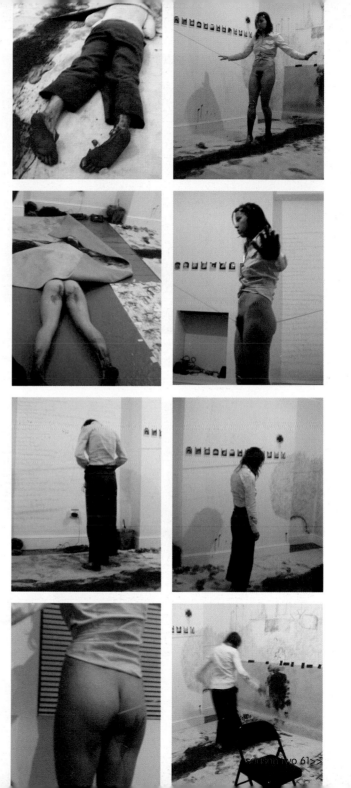

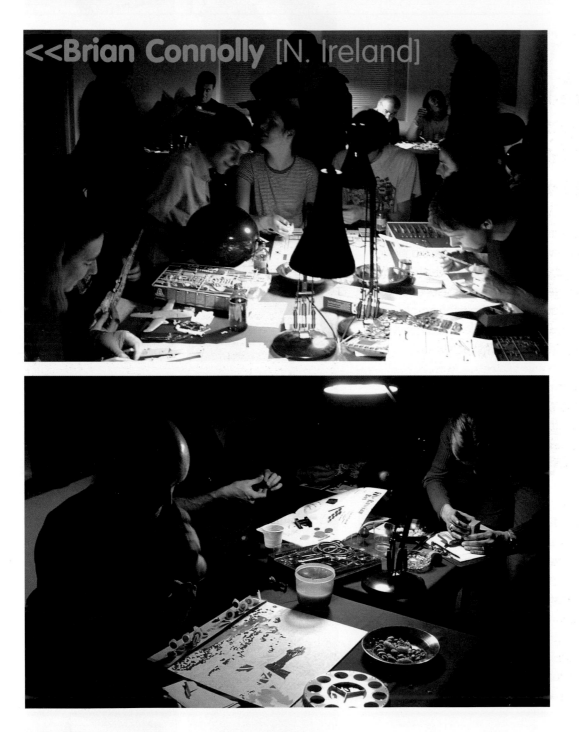

<<Brian Connolly [N. Ireland]

"Initiate"

**performance 18:00
2nd March 2002
installation exhibition
3rd–24th March 2002**

Brian Connolly embraces a range of contemporary art forms and media to reveal evocative, sometimes hidden, layers of a particular place. His work passionately challenges societal views of history, culture and politics and he attaches particular importance to considering the role of art within contemporary culture. He has participated extensively in artist-initiated projects in Europe, Canada, Mexico, Ireland and the UK, and initiated artists' projects including the influential 'Available Resources' in Derry. He is a board member of the Artists Association of Ireland, the Sculptors Society of Ireland and a member of the editorial board of *Circa*.

Connolly initiated a series of games, activities and tasks as host and facilitator. These activities created a layering in the hope of drawing comparisons with the complexity of contemporary existence within an increasingly globalised economic structure. The meeting between artist and audience created a complex collaboration with the public turning the gallery into both war room and demolition site. "I would also be delighted to contrive a sense of visual absurdity and fun in our endeavour... Something will be left for posterity."

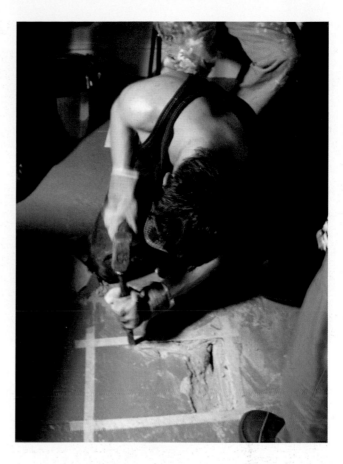

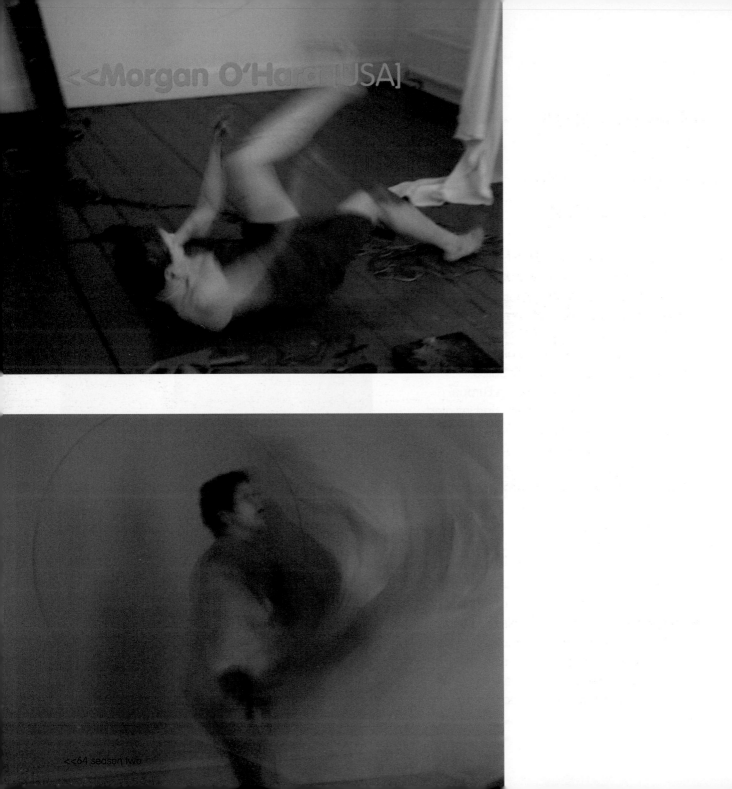

<<Morgan O'Hara [USA]

<<64 season two

"Live transmissions"

**performance 18:00
20th April 2002
installation exhibition
21st–28th April 2002**

Morgan O'Hara's childhood and adolescence in an international community in post-war Japan early established close relationships between east and west, creation and destruction, life and art. Her work falls naturally into two parts: TIME STUDIES, which she has done on a daily basis since 1971 and time-space work: PORTRAITS FOR THE TWENTY-FIRST CENTURY and LIVE TRANSMISSIONS. The latter have resulted in many interdisciplinary collaborations. O'Hara's strong link to the international new music scene is evident in performances with Anthony Braxton in New York at the Knitting Factory and the Tri-Centric Foundation Festival and with the Work in Progress Ensemble in Berlin which performed musical compositions based on her drawings at the Hamburger Bahnhof (Berlin's Museum of Modern Art).

The point of live contact between eye and subject and between pencil and paper is essential to her work. She performs with people of all walks of life, thereby shortening and perhaps dissolving the boundaries between art, criticism and life. For her work at Trace, Morgan O'Hara investigated notions of the trace in relation to the body as flesh passing through time & space.

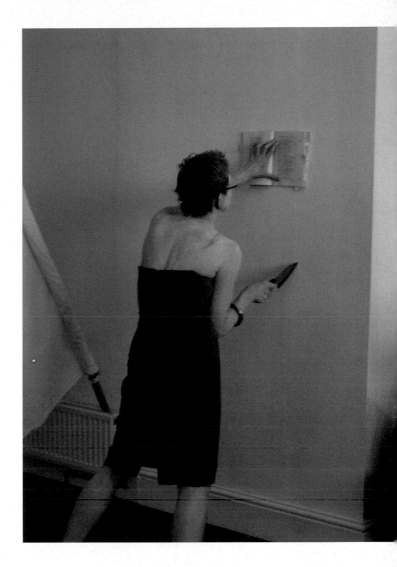

<<Zbigniew Warpechowski
& Jerzy Beres [Poland]

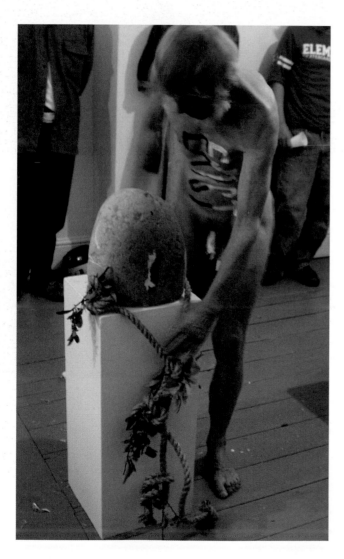

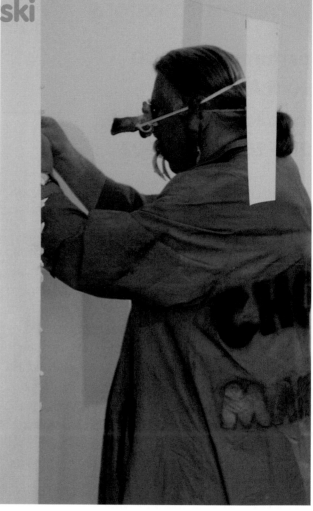

"InterPol"

**performance 18:00
4th May 2002
installation exhibition
5th, 12th & 19th May 2002**

Having made live work since the 1960s, Warpechowski & Beres are Poland's oldest exponents of performance art. Their artistic practice is epitomised by evocations & traumas as experienced through the often dramatic events in their native country and Eastern Europe.

The artists each presented a solo work that evidenced the diversity and differing approaches of their practice. While Warpechowski's work can often be disruptive and violently cathartic, Beres evokes a rare and tranquil lyricism. Both artists last presented work at Chapter Arts Centre in Cardiff in 1979. Their show at Trace was a very rare opportunity and a welcome return to experience first hand their generous and thought provoking actions.

"Performance cannot be defined, but it can be codified. I know this code for me. My code of performance is only for me. Your code can be similar, but it must be different." – Zbigniew Warpechowski

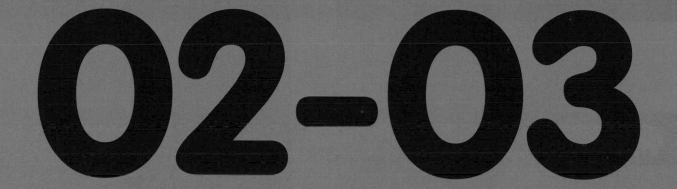

<<Istvan Kantor aka Monty Cantsin [Canada]

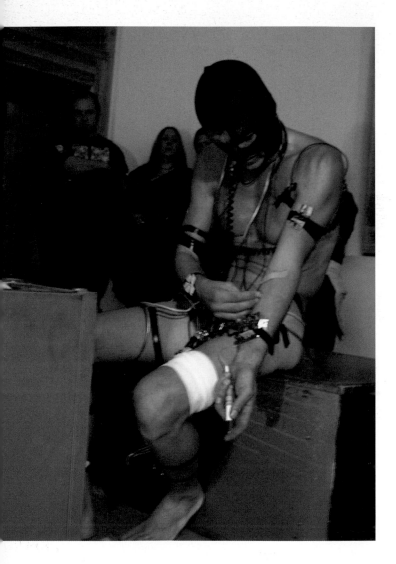 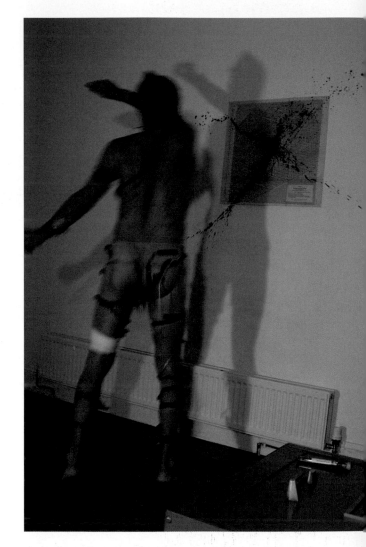

"Machinery"

performance 18:00
19th October 2002
installation exhibition
20th–27th October 2002

Veteran cyberpunk space cadet, founder of
international Neoism, Istvan Kantor AKA Monty
Cantsin is based in Toronto. His near legendary
status as enfante terrible of the underground has
ensured his work has been presented at high and
low art venues throughout the world.

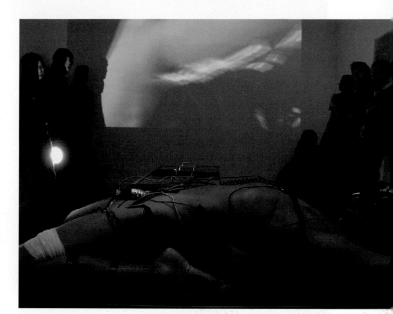

Utilising filing cabinets with live action, sound and
video, Machinery explores the socio-mechanical
bodykinetics of communication systems and their
relationships to individual and collective "body-
machines" extended with new technology. The File
Cabinet Project represents Kantor's observations
concerning information systems in technological
society. The artist's interest in the file cabinet is not
simple physical fascination or aesthetic obsession;
rather a wider theoretical involvement with semi-
robotic sculptural systems and kinesonic information
mechanisms. The monolithic file cabinets are linked
together by computers and integrated into a giant
network that functions as world wide information
reproduction machinery. The body as a transmission
device, orgasmic contractions as kinetic control
system, epileptic seizure of the body as information
machinery.

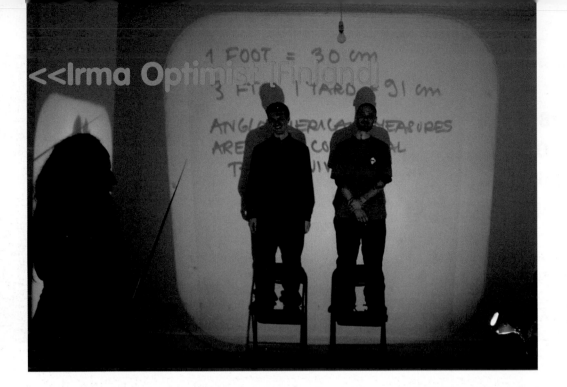

1 FOOT = 30 cm

3 FT 1 YARD 91 cm

ANGLO AMERICAN MEASURES
ARE COLONIAL

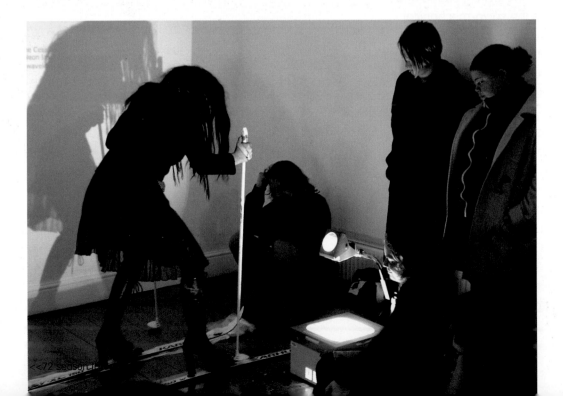

"Potato phone"

**performance 18:00
2nd November 2002
installation exhibition
3rd–24th November
14:00–18:00**

What happens when an engineering consultant is a hot potato. World's flesh peeps, flickers and shines. Communication is geometry. Why does my electric skin glow more than the coal in the grill? Is it really that communication works as sounds on semiotic fields and as dialogue between them? We want to peel our potatoes in peace, but we fear that the silence of a sheepskin coat is forgotten in the message of the shepherds.

Electric guards observe our joy from the level of their tele-consciousness. Can any message be a reply? Desire returns to abstract velocity. What kind of traces do the steps in space leave behind? I, too, have my weight and you have your weight: we do have our weight. But how much do we weigh? My velocity lies in my being three-dimensional. What if I begin to slow down? Some kind of organic turbulence, or?

Irma Optimist (D.Ec) from Helsinki, Finland, is a performance artist and senior lecturer in mathematics at Turku School of Economics and Business Administration, her research area being chaos theory. In her performances, Irma Optimist combines the female view of the real world with the world of abstract mathematics. She intends to produce interferences on the field of scientific logic. Her performances proceed through minor catastrophes to a resolution which can be either static harmony or total chaos.

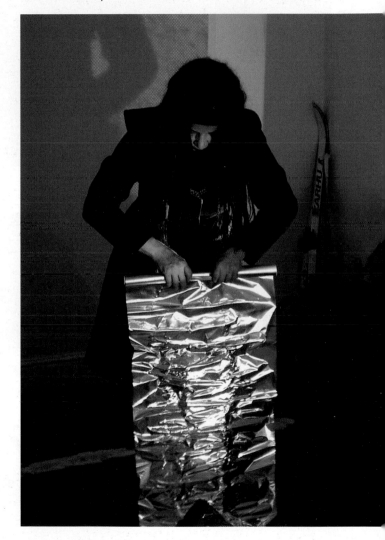

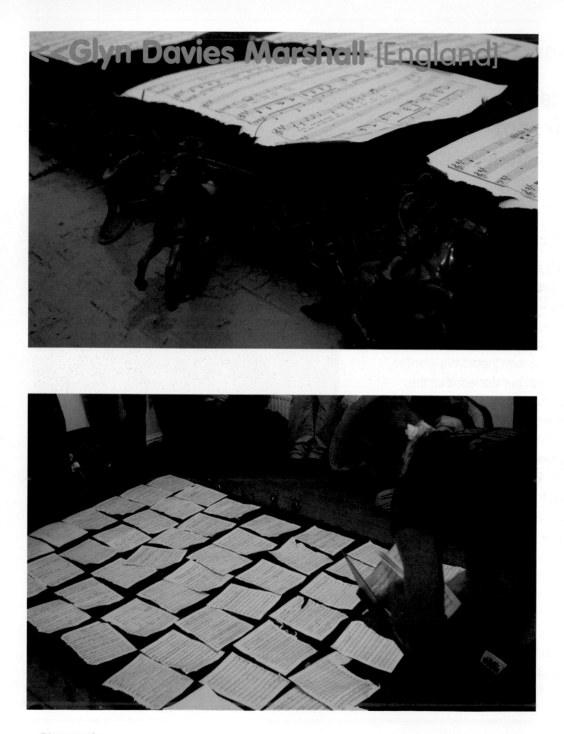

"Somewhere between Wakefield & Wichita, the eagle has landed"

**performance 18:00
30th November 2002
installation exhibition
1st–22nd December 2002
14:00–18:00**

Glyn Davies Marshall is one of the great undiscovered voices of British performance art. An artist who combines a unique understanding of process combined with the manipulation of objects and materials to create strange and secretive juxtapositions of reality. His work resonates with humour and gut wrenching pathos.

Glyn Davies Marshall has made Performance On Film for BBC2 and regularly produces performance and installation work in Europe. Over the last five years his work has been concerned with THE SYMBOLIC ORDER, the language of his father and the legacy of a northern upbringing.

" 'The Eagle has landed' is a piece born from embarrassment, it has been a long time since I have witnessed THE ORDER displayed in such a precise and calculated way."

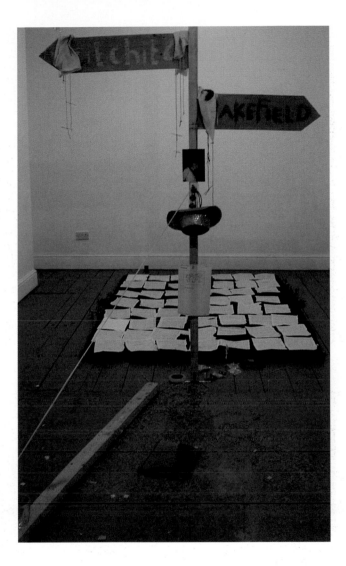

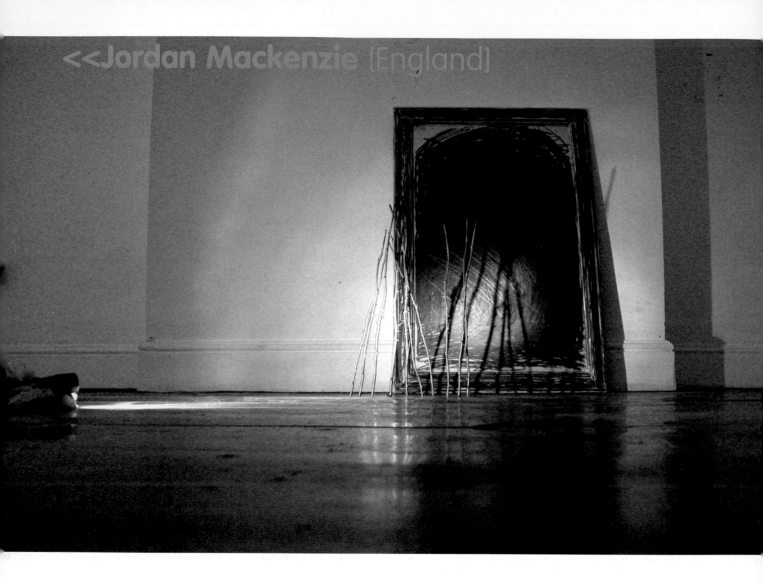

"Untitled [body/mark]"

**performance 18:00
11th January 2003
installation exhibition
12th–26th January 2003
14:00–18:00**

Jordan Mackenzie's work has traversed the territories of investigations into obsessional behaviour and 'queer' culture, creating difficult and contentious work centred on the body. Recent work has extended his interest in relation to the physicality of drawing, most notably at the Arnolfini in 2002 with a durational installaction exhibition, 'Untitled [DIE]'.

Mackenzie continued his investigation into drawing as a performative act with body/mark, a series of drawings that consider the body as site. Drawing explored as an action that articulates the body in space, a way of locating the body within architectural place. These actions cross the lines between performance, drawing and sculpture, meeting at a point where the body and the mark break through the terrain of traditional definition and establish new dialogues and relationships.

Jordan Mackenzie has produced work throughout the UK and Europe. He received his MA at Nottingham Trent University where he now teaches.

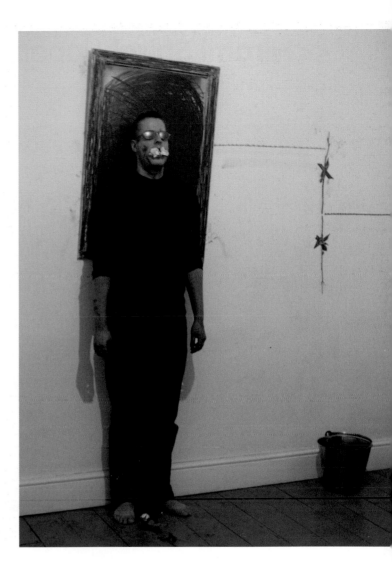

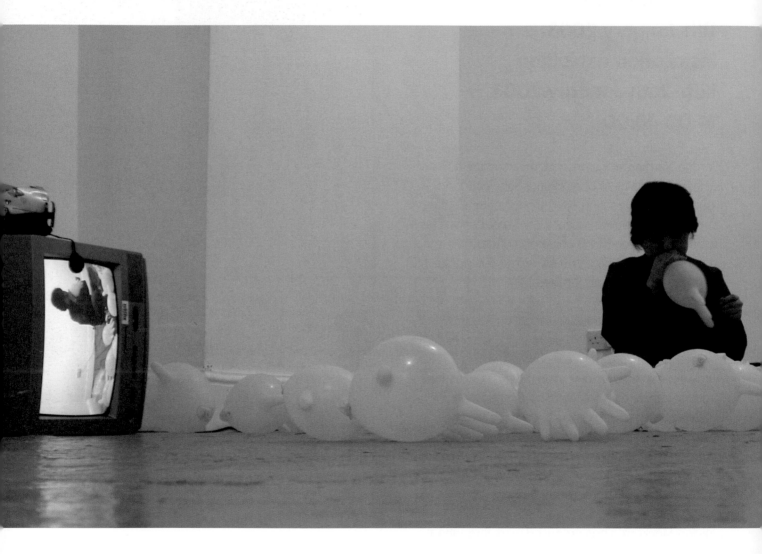

<<Hiromi Shirai [Japan]

"Welcome to my cosy corner"

**performance 18:00
1st February 2003
installation exhibition
2nd–23rd February 2003
14:00–18:00**

'I think breath is breathing in all of our environment, and breathing out our sense through our bodies.' In this work, I inflate several hundred gloves with people. Once I release an inflated glove on the floor, it mixes with many others. Mine becomes other's. Other's become no ones. You can sense other's. Its sense could be unforgettable.'

Since graduating from Cardiff School of Art in 1997 Hiromi Shirai's work has been discreet and magical. She has produced numerous performance installations in her native Japan as well as shows at the Daiwa Foundation in London, the Japanese Embassy, Paris, and venues throughout south east Asia. She recently participated in several exhibitions in Taiwan. Shirai has also produced festivals and events in her home city Kobe, Japan, where she is now based.

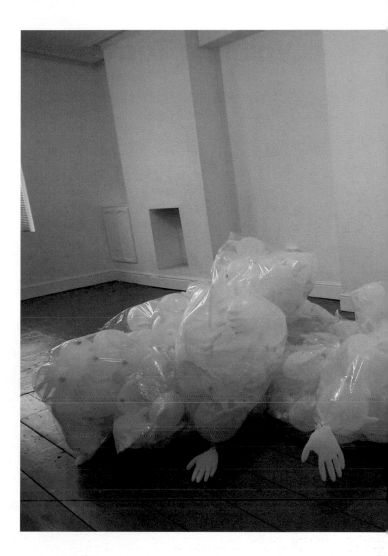

<<**Valentin Torrens** [Spain]

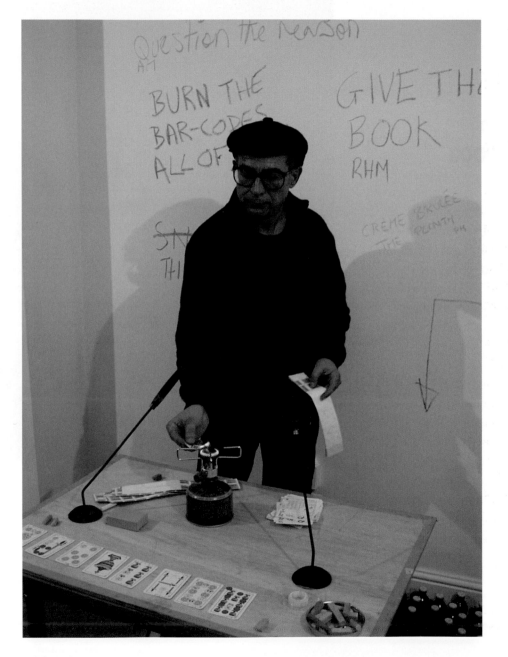

"The bet"

**performance 18:00
1st March 2003
installaction exhibition
14:00–18:00
2nd–23rd March 2003**

Valentin Torrens proposed an interaction with the audience based on his personal interest in illusion and trickery. The audience were asked to place bets using beer as currency to forecast the probable development and outcome of the performance. Using a specially designed set of playing cards Torrens used dexterity and wilfulness combined with his own anarchic and idiosyncratic actions. These often involved smashing tables and setting books on fire to question our certainty of what was actually taking place.

From Barcelona, Torrens has been making performance actions and installations since the mid-1980s. He has produced work throughout Europe, USA and South East Asia. His art practice continually explores the relationship between reality and illusion.

"Our children"

performance 18:00
5th April 2003
installation exhibition
6th–27th April 2003

James Cobb and Bobdog Catlin created a live sonic backdrop to digitally manipulated images of children. The outcome was disturbing and provocative. "The most striking aspect of these children is the new skin the artist has given them. Other than their hands, faces and the plaid underpants they wear, their skin is a welter of tattoos. The tattoos come from a wide-mouthed river of sources – religion, botany, popular culture, and zoology, among others. That breadth makes them resemble the archive of references bequeathed to all of us from birth, as we become socialised. The artist thus weaves together our cultural-historical memory and makes it visible on the litmus paper of the skin. He could be depicting members of a different species, or he could be showing us ourselves, if enculturation were a lightening strike and tangible."

James Cobb's images are a natural extension of his paintings and his audio work a natural progression within the digital process. OUR CHILDREN is a series of light-jet prints of children scanned and manipulated on computer. The full-body "illustrations" provide a layer of free-associative narrative with a large nod to traditional tattooing

themes and motifs. It is this associative aspect coupled with the use of children that seems to provoke highly individual responses to the work. The audio performance was composed from the voices of these same children and provides another layer of associative narrative. The sonic work is performed using laptops and LIVE software. Based in San Antonio, Texas, Cobb & Bobdog are members of experimental sound group Pseudo Buddah. They promote events in Texas and distribute audio work via their DogFingers record label.

<<Louise Liliefeldt [South Africa]

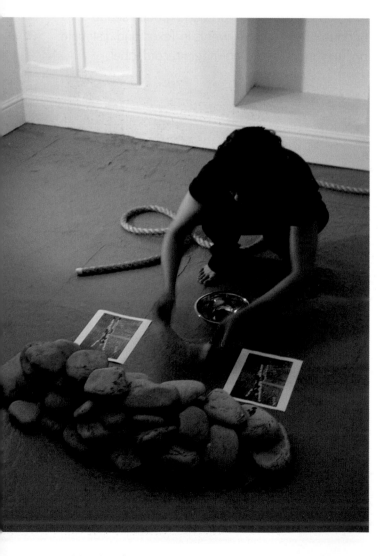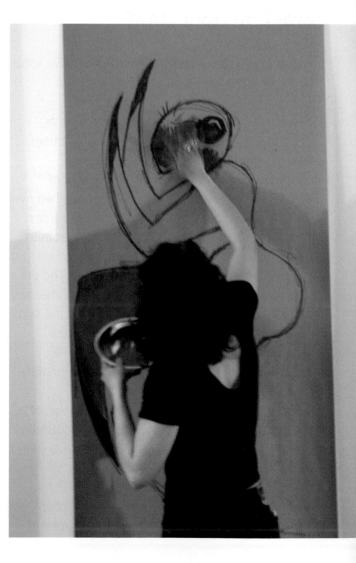

"Cage"

**performance 18:00
10th May 2003
installation exhibition
11th–25th May 2003
14:00–18:00**

From South Africa and based in Toronto, Louise Liliefeldt's work is predominately concerned with the politics of identity as it intersects with issues of gender and race. Since the 90s she has been instrumental in setting up and organising artistic collectives and events in Toronto, most notably the 7a*11d International Performance Art Festival which to date has featured over 140 local and international artists. She has also presented her own work throughout North America and Europe.

"For ten years I created performances that were concerned with stasis where control and discipline were held predominately in the body. I was creating great tension as the madness held itself tightly in my psyche. It may have appeared to the viewer that I was extremely disciplined and in great control but I believe my mind and body were rarely working in sync. In the last few years I have been working on more action-based performances. In the case of these recent works my mind and body were working together, responding to one another. This process is still new for me and in Cage, a very personal piece, I intend to work through some of these challenges. Psychologically Cage is further development into a piece I performed in 1999 in Québec City giving expression to a traumatic experience. Physically I am attempting to rectify a performance gone wrong."

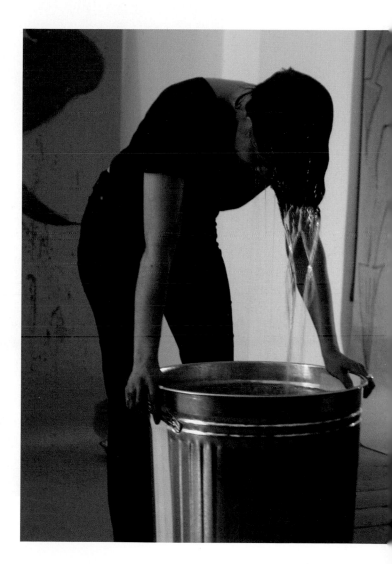

03-04

<<James Partaik [Québec]

"America's most wanted"

performance 18:00
9th October 2003
installation exhibition
10th–26th November 2003
Presented as part of RHWNT
Trace: Wales-Québec exchange

Partaik's audiovisual, object-based and interactive 'InstallAction' has a title that hints at the wider political implications of the work. The piece was specifically 'grafted' to the space of Trace gallery, using preconceived components complemented with materials found in Cardiff. It is through this kind of site-related practice that Partaik explores the stakes implicit in creative acts, acts that open themselves up to what is invisible or potential in every situation and thereby tangibly transforming reality.

This highly prolific artist has created numerous installations, interventions, performances and audio works, which have been presented extensively across the world. He has initiated and facilitated many artist-led projects in Québec and Japan. He is a founding member of ARQHÉ, a collective which examines the relationship between art, architecture, landscape and multimedia, and AVATAR, pioneers for their creation and dissemination of audio and electronic art in the context of media arts, notably through their innovative use of the internet. Partaik lectures at Laval University in Québec City, where he teaches video and new media art.

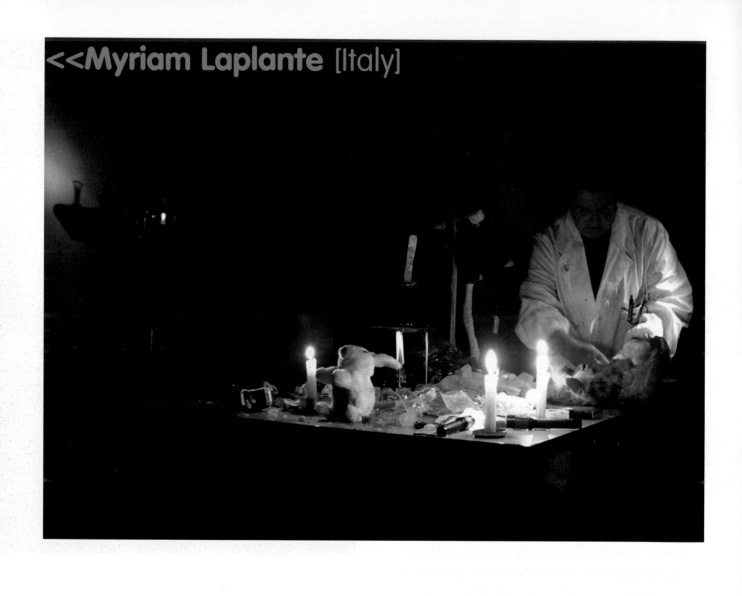

<<Myriam Laplante [Italy]

"Everything is going according to plan"

**performance 18:00
1st November 2003
installation exhibition
2nd–23rd November 2003**

All over the planet, powerful nations are trying to rule the world and smaller powers are trying to stay autonomous. Other rulers just try to get all they can while it lasts. All this is done 'for the good of humanity'. The more they mess up, the more they say it was all planned this way. The performance acts as a parody of secret military research laboratories that exist all over the planet.
Myriam Laplante was born in Bangladesh in 1954, grew up in Québec and is now based in Rome. Her work has been exhibited throughout Europe and North America.

"...the work of Myriam Laplante has false bottom moods. On the surface, her tales of common folly, with grotesqueness, combine cynicism with mockery, the works are crude, biting and solemn. A curious and humble lesson about the human zoo that is the world, they are surprising in their material and dramatic outrageousness, and tip art in the direction of the theatre of life." – Louise Dery, The Parody of The Worlds According To Myriam Laplante

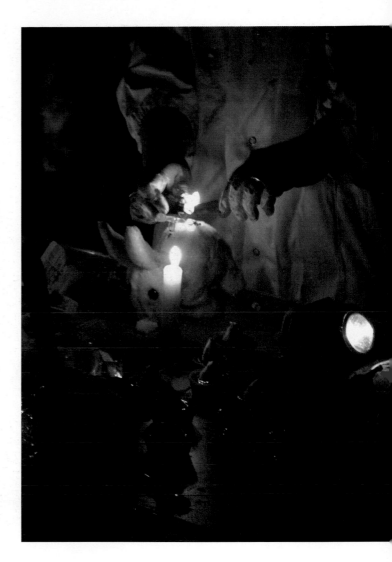

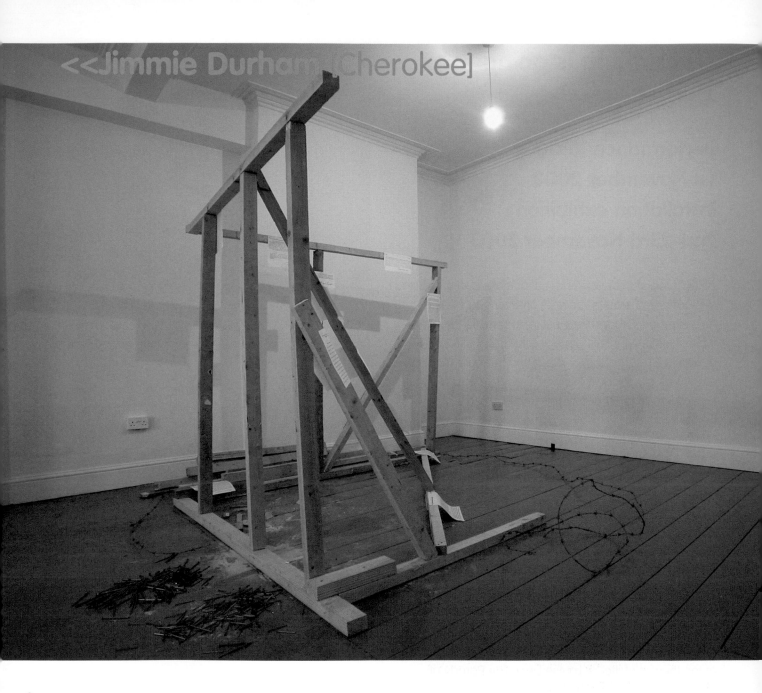

"Building the nation"

**performance 18:00
6th December 2003
installation exhibition
7th–20th December 2003**

Jimmie Durham is an internationally acclaimed artist, writer, poet and performer of Cherokee descent. His intricate sculptures and installations mimic the attributes of humans and animals, and the ways they make or are made into history. His work at Trace investigated these recurrent themes in relation to the USA and issues of colonisation and imperialism.

An activist in the American Indian Movement [AIM] during the 1970s, Durham has published numerous books of poetry, fiction and critical theory. His work has been exhibited at Documenta, Whitney Museum, New York, Ghent and Brussels Museums, ICA, London and is shown regularly at all the major International exhibitions, museums and galleries. His most recent work was exhibited at the Venice Biennale and Sydney Biennale in 2005. He has held recent retrospectives in Marseilles, France and Sunderland, England.

"I wish I were a better artist. I wish you knew how good I am. (So that you could help me) I wish I could find the missing pieces."

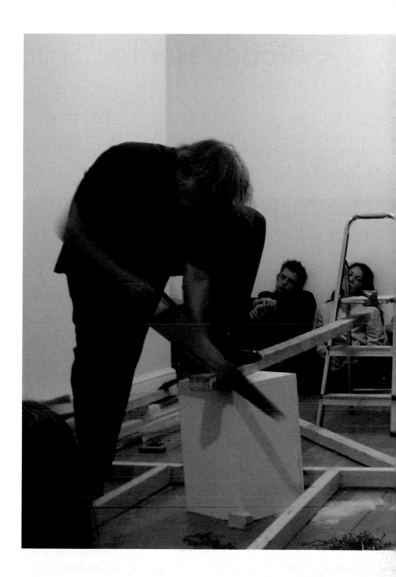

<<Roddy Hunter [Scotland]

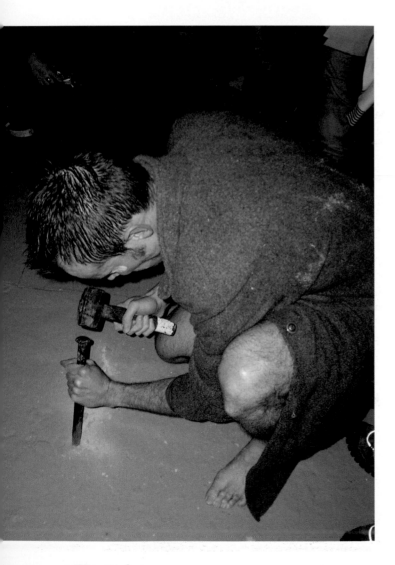

"[The noise of] the street enters the house"

**performance
18:00 10th January 2004
installation exhibition
11th–25th January 2004**

Roddy Hunter's work synthesised together in an installation, an 'integral construction' entitled '[The Noise of]The Street Enters The House [The Noise of] The House Enters The Street'. This concerns the psychic effects of urbanism upon domestic and public space. Umberto Boccioni's painting 'The Street Enters The House' provided an axis to consider these concerns. A digital reproduction of the painting taken from a page in a little Hungarian book on futurism hung on a wall above the lightbox...

"So, here's what happened. I rolled up the blinds and opened the windows to let the sound from the inside meet the noise from the outside. I'd waited for the room to go quiet. I rolled the blinds back down so we'd think more about aural rather than visual concerns and because I was probably going to take my cloths off later... oh, yeah, and we wanted the room to be cold, really cold... I opened the windows chalked a crack from the window across the floor, sat at the lightbox, looked at slides, took the temperature, went to mattress, took the temperature of the bird, put elastoplasts on my eyes, so I couldn't see, undressed/dressed in old coat, asked for hammer and masonry chisel, made a new crack across the floor, dressed, placed thermometer on lightbox, looked at slides, chalked line and closed the windows."

'Why can't we live together?'

<<**Amanda Heng** [Singapore]

"Smile. I am a Singapore girl!"

performance 18:00
7th February 2004
installation exhibition
8th–22nd February 2004

The iconic Singapore Girl, in her Pierre Balmain-designed Kabaya, has been flashing her famous smile and bringing huge profits for decades.

Amanda Heng is concerned with the construction of the Singapore Girl image as a representation for promotion of the economical consumption, its implications for female identity and gender politics in the patriarchal society of Singapore. Heng deals with the clashing of Eastern and Western values, traditions and gender roles in the context of the multicultural, fast-changing society of Singapore.

Amanda Heng has produced performances, collaborative interventions and installations throughout South East Asia and Europe. Heng is hugely influential in the setting up, curating and producing of numerous women's projects, exhibitions and events including: 'Women And Their Arts' (1991); 'The Space' (1992); 'Part of The Whole' (1994); 'Memories and Senses' (1994); 'Artists Project' (1994); 'Women About Women' 1998; and 'The Friday Event' (2000).

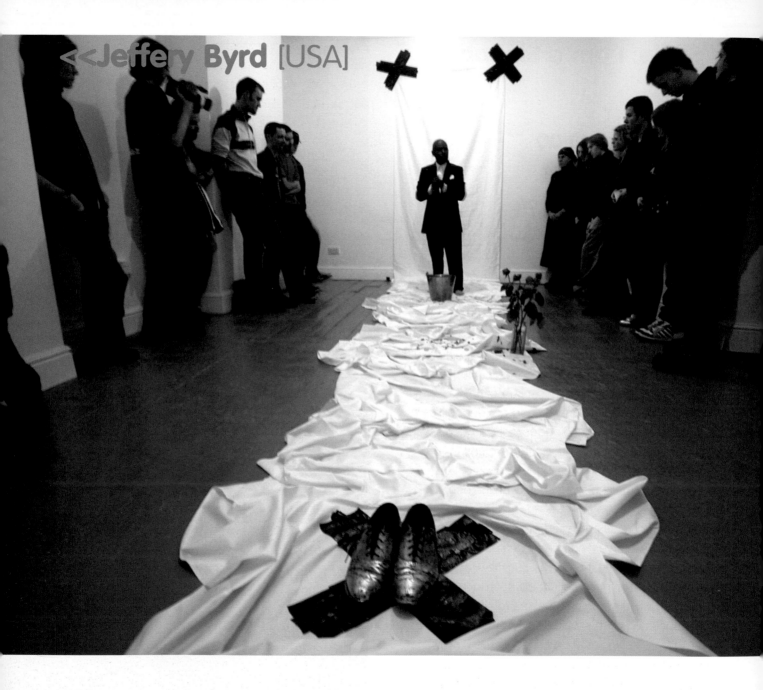

"Holy ghost"

performance 18:00
6th March 2004
installation exhibition
7th–28th March 2004

"'Holy Ghost' is a piece that relates to my childhood in rural Alabama. Jesus was everywhere and for a little boy that was a rather scary thing. The rough dissonance of Southern voices in song seemed to tap into a world beyond the corporeal. This piece is ultimately a plea for forgiveness. The question is who is meant to hear the plea? While I have left behind many aspects of the belief system of my heritage, the language still remains. The debt must still be paid whether the transgressions are personal or global. While my work is often based on specific auto-biographical information, the results are often open-ended and ambiguous. I invite the interpretations of others and often think they are as valid as my own."

Jeffery Byrd is a photographer and performance artist whose work has been widely shown throughout the US. He has had solo exhibitions in New York, Minneapolis, Philadelphia and Portland. He has performed at the Lincoln Center, DCTV, Greenwich House and the Alternative Museum in New York, Chicago's N.A.M.E-gallery, Boston's Institute for Contemporary Art, Full Nelson in Los Angeles, the Cleveland International Performance Art Festival and the Indianapolis Installation Festival.

Byrd's elegantly minimal art explores the metaphoric potential of the human body through video, movement, original music and otherworldly vocals. Born and raised in Alabama, much of his work connects the spiritual with the physical and translates autobiography into symbolic actions.

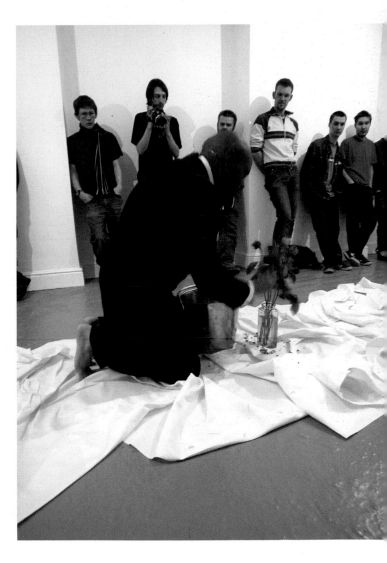

<<Danny McCarthy [Ireland]

"Wild oats and cornerstones"

**performance 18:00
3rd April 2004
installation exhibition
4th–25th April 2004**

To heal the fractured birdsong, the injured child, the divided self, the wounded land. To demythologise the myth, to heal the healer. Our destination will be where we begin. The 'end' is the 'beginning'. Only the journey is important.

Through what we see on the journey, how we experience the journey, how we live the journey, we will be prepared for reaching the final space and knowing it for the first time. The space will not have changed, we will have changed, not by reaching our destination but by making the journey.

Danny McCarthy's work often thematically centres upon icons and experience of 'Irishness'. He pursues this recurrent theme in a range of media including performance sonic art, installation and public sculpture. He is an important figure on the Irish art scene having produced and directed numerous arts events and projects as well as being the founder of Triskel Arts Centre in Cork , Ireland's leading live art venue. McCarthy's work has been exhibited worldwide.

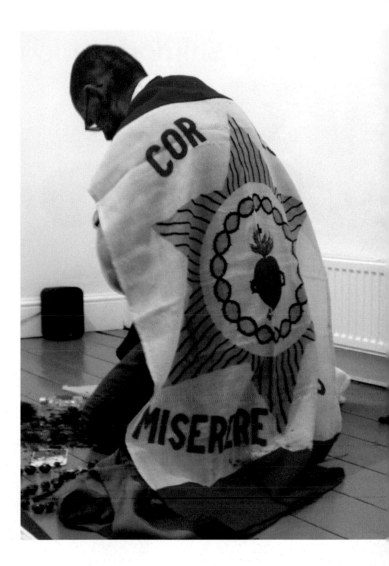

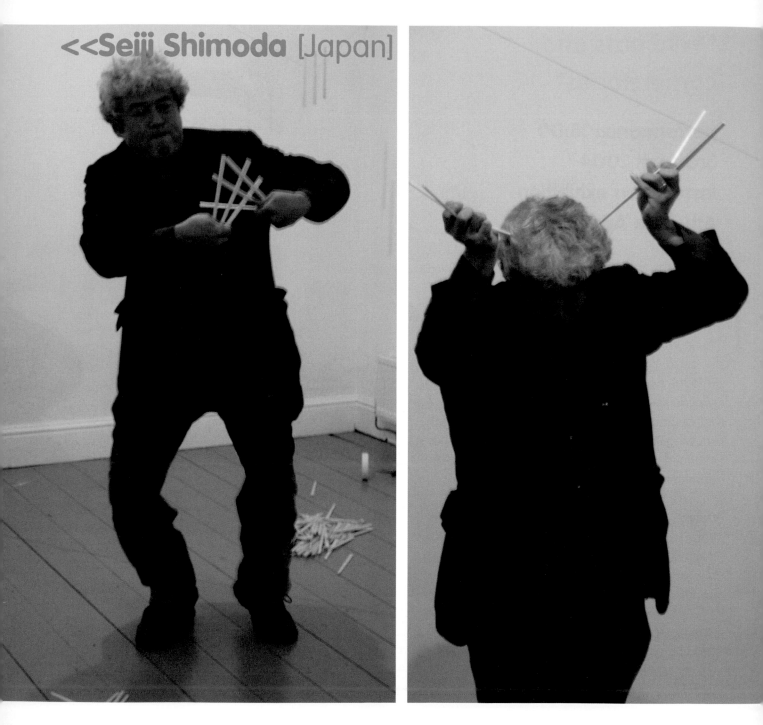

<<Seiji Shimoda [Japan]

"Chopstick action"

performance 18:00
1st May 2004
installation exhibition
2nd–23rd May 2004

Shimoda is one of Japan's most prolific contemporary performance artists. Having started making live works in the mid 1970s by travelling throughout Japan making 'art actions' at alternative venues; this has lent his itinerant lifestyle a unique identity, remaining rooted in the ideals of social mutual-aid and artist networks.

In 1979 he produced the now legendary 100 performances at Kid Ailack Art Hall in Tokyo followed in the 1980s and 1990s by extensive travel and presentations throughout the world. Shimoda's famous piece 'The Table' was performed in over 150 international art festivals in 37 countries throughout the 90s. He presented this exhausting and contemplative piece in Cardiff in 1995 and 1996. He says, "I am in search of a new way of conceiving the sense of the human being in society, and defining the image of the human body. The table, as a cultural product constructed by the human being, has the function of gathering people."

The notion of gathering people is further articulated in Shimoda's commitment to presenting international contemporary performance art in Japan through his directorship of NIPAF (Nippon International Performance Art Festival) which he started in 1993. The influence of Shimoda and NIPAF has enabled many artist-run projects and festivals to be initiated throughout South East Asia. Seiji Shimoda's work is often pared down, minimal, austere and intimate, leaving one space for reflection, contemplation and meditation.

"Singing body, imagination for the world, courage to shout."

<<Uri Katzenstein [Israel]

"Vehicles"

**performance 18:00
2nd October 2004
installation exhibition
3rd–24th October 2004**

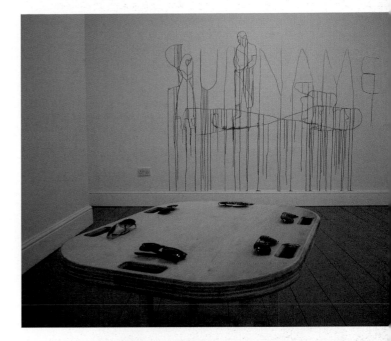

"Dreamscapes, changed identities, possible vehicles, roots, and songs. Blood writing, territories of faith. With the help of these metaphoric images and actions I may refer to any number of hybrid units that form the basis of interpersonal similarities and preferences. My thoughts, images and actions are taken from the cultural, psychological, and/or emotional to biological, intellectual structures and relations. The gathering of such known phenomena, inter-mixed with sculptural sensibilities makes place for an arena of the invented culture."

Uri Katzenstein is one of Israel's most accomplished and renowned live performance and interdisciplinary artists. He studied at the San Francisco Art Institute in the late 1970s, then moved to New York City, becoming a regular at such legendary performance venues as The Kitchen and The Knitting Factory. His often visceral actions combine with music and manipulated sound to create a physical, visual and sonic attack upon his audience's senses and sensibilities. Now based in Tel Aviv, he represented Israel at the Venice Biennale in 2001.

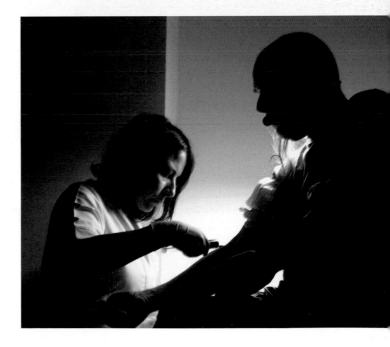

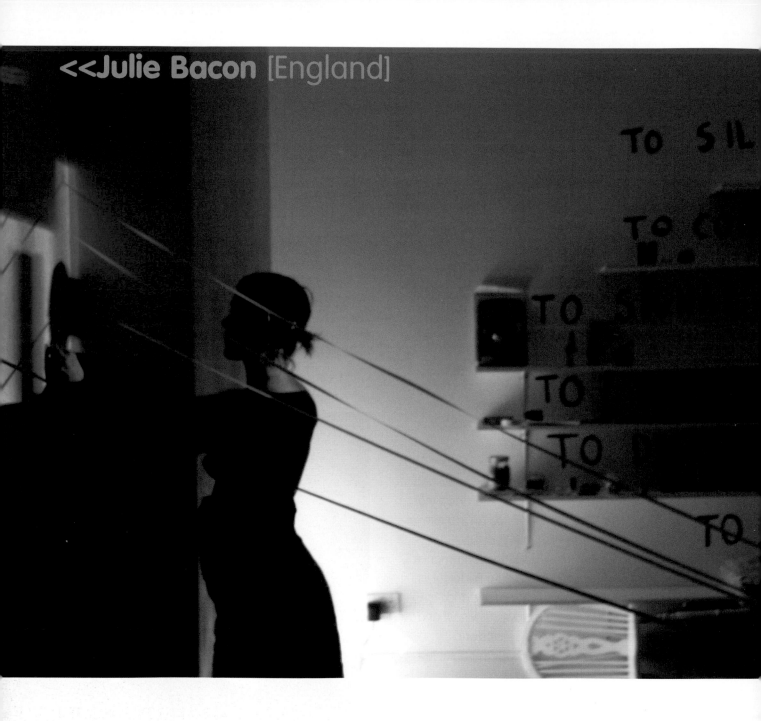

<<Julie Bacon [England]

<<108 season five

"In stilling"

performance
6th November 2004
durational performance
12:00–18:00
final action 18:00
installation exhibition
2nd–23rd November 2003

A love-embrace with life and its shadows.

Concerning the death of the artist's mother, communal and private space, grief and redemption.

Julie Bacon was born in 1972 in South Shields, Tyne & Wear. She has presented performances and installations, at home and overseas, since 1994, and throughout this time has played an active role in a number of artist-run centres, including Hull Time Based Arts, England, and Espace Virtuel Chicoutimi, Canada. In 2003-2004 her work was shown in sites including Full Nelson 5, Los Angeles; Coalition, Santiago/Valparaiso, Chile; Bone 6, Berne Switzerand; Grunt Gallery, Vancouver; and Open Space, Victoria, Canada.

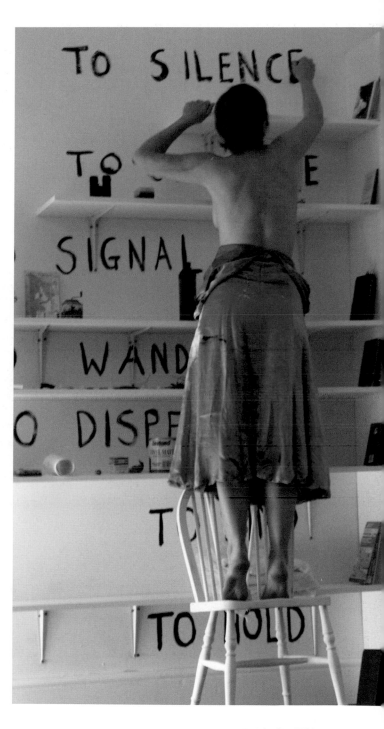

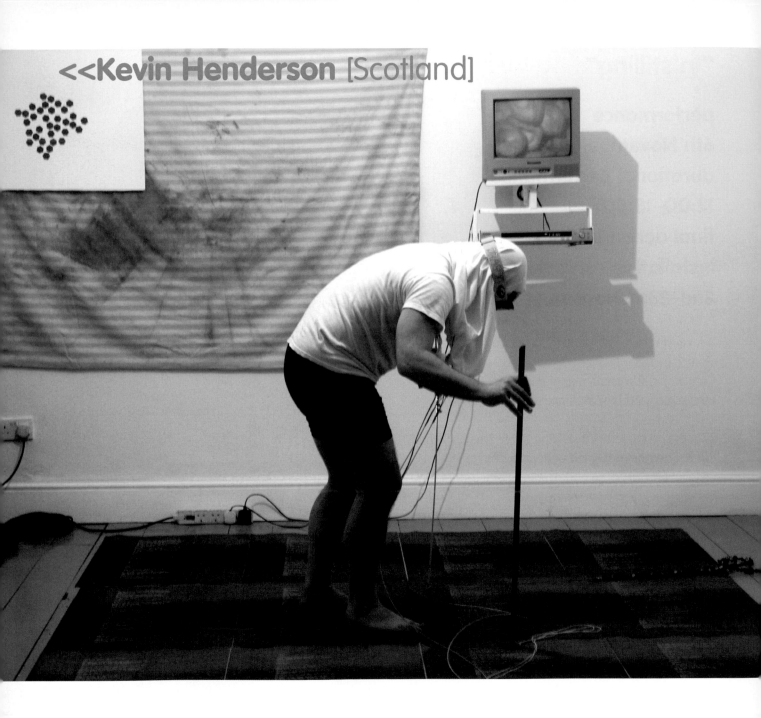

"In the hunting with dear and the heart of Charles"

performance 06:00–18:00
4th December 2004
installation exhibition
5th–23rd December 2004

"The work was invoked by an actual event that was reported in the media, the murder of a teenage girl in Dalkeith (Scotland), and this is still evident in the drawings and objects installed in the gallery as a matrix of references, allusions and images. This was no reconstruction of a setting, instead it reflected on the event in a broader sense, through diverse, and not always explicable creative acts. The work focused on the political implications of beings in the same spaces: it is a meditation on self and community, as a performed belonging that explores that which I think is perhaps most difficult for us to think about, contemporary forms of society."

Kevin Henderson is head of the MFA programme at Duncan of Jordanstone College of Art, Dundee University in Scotland. An important contributor to the debates and discourses of art in Scotland, he has produced work throughout Europe and north America. Henderson is also widely known through his poetry and other published work on poetics.

<<Sinéad & Hugh O'Donnell [Ireland]

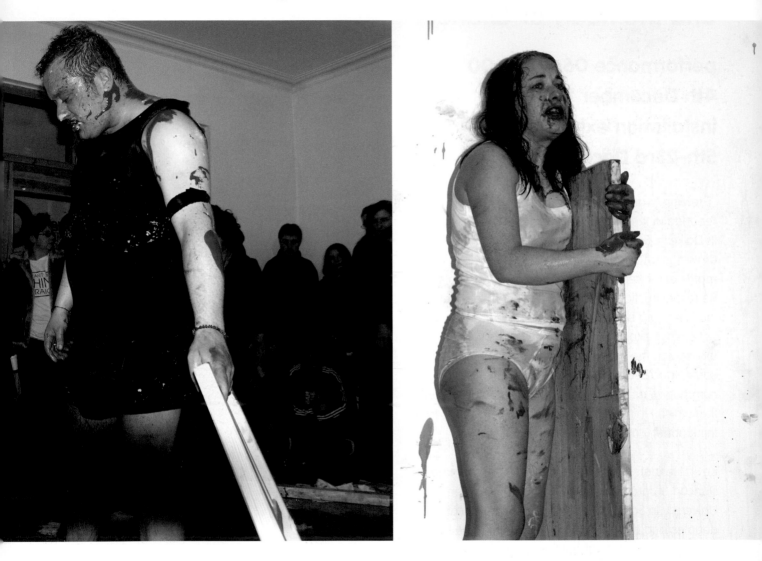

"Gravity"

**performance 18:00
15th January 2005
installation exhibition
16th–30th January 2005**

"Our names are Sinéad and Hugh O'Donnell. We are brother and sister. We make actions together. He thinks, Hugh that is, about his anus a lot and she, her, your one, Sinéad that is, thinks about her blood. She and him have been doing this for years now. Since 1978. She was on her own from 1975. Then he came.

Gravity became more obvious, more obvious to her the female. More obvious to him the male. The brother, the sister, inside our mother.

Gravity, a term that defines, $F=G\, M1M2$, inside our mother R2 Collaboration. It was so close in front of us we nearly didn't do it. Gravity actions re-established our relationship. Now we will do it again.

Anticipation of aftermaths. Aftertrace, inside our mother. Sister,Brother. Male,Female. Man,Woman. They, that is Hugh and Sinéad reach their ultimate freedom inside the practice of performance. It is part of them now. It's not just a definition. Art practice. It's a fucking reality. See they can't live without it now. Gravity action. Art cunt mother fuckers, inside our mother.

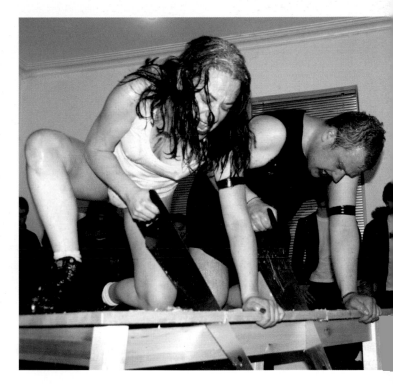

<<Peter Baren [Netherlands]

"ARK (frozen footage)"

**performance 18:00
5th February 2005
installation exhibition
6th–27th February 2005**

"Everything you are about to experience has been
put under the spell of a floating device (BLOW BLOW)"

Peter Baren's work is mysterious, enigmatic and
defies classification. His recent works include:
CURRENCY 2004 Festival. NYC (US), International
Performance Art Festival, Cleveland (US) 2004, Tate
Modern, London (UK) 2002-2003, TransArt
Communication, Slovakia 2002. He has presented
work at an international level since the early eighties
throughout Europe and the USA. Peter Baren has
also received the Prix de Rome Art & Theatre award.
He lives and works in Amsterdam.

<<High Heel Sisters [Scandinavia]

Malin Arnell, Line S. Karlstrøm & Karianne Stensland

"Art holes"

"Stand piece"

performance
2nd March 2005
5th March 2005 18:00
installation exhibition
6th–27th March 2005

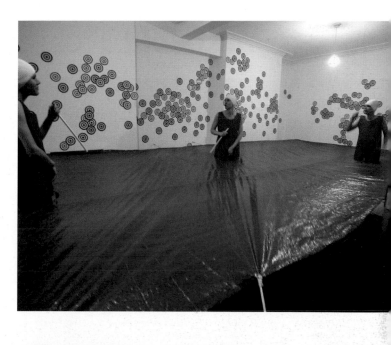

The High Heel Sisters' work takes as its starting point the mutual and diverse experiences of being taller than 178 cm, wearing shoes bigger than size 41 and being older than 30 years. These common experiences are aimed at making a feminist attack on our own, as well as on the rules and boundaries of society. HHS work within the field of poetic politics!

The three members of High Heel Sisters began collaborating in 2002 and since then have showed their works throughout the Nordic countries and internationally. Their back catalogue consists of gallery based and site-specific performances and includes 'Art Holes', Lars Bohman Gallery; The Projectroom in Stockholm, Sweden, and Three Pieces by HHS, Blunk Project Room, Trondheim, Norway. They were invited to make their performance piece 'Never Too Much' at the ICA, London, in 2003 and at Black Box Kilen, Culturehouse, Stockholm, Sweden in 2004.

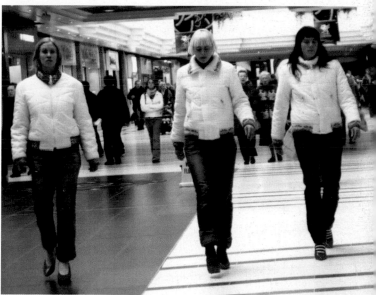

"Naive exhibition"

performance 18:00
2nd April 2005
installation exhibition
3rd–24th April 2005

Cyril Lepetit was born in Cherbourg, France, studied at the Ecole Superieure des Beaux-arts de Caen and the Ulster College of Art, Belfast. After living in Paris for several years, he spent four months on an art residency in Japan and Taiwan in 1999. Since 2000 he has been living and working in London. In 2005 he had his first major solo exhibition 'Infidelite Respectuseuse' at the Normandy Contemporary Art Centre, France. He is curator of 'International Exhibitionists' at the Soho Curzon Cinema, London.

"In creating devices or putting into place actions, in contexts I've borrowed from reality, I create situations that I call 'fantasised'. They deal with sexuality, and with existence. They are usually devised to receive visitors, in the expectation of their reaction, of their taking a stance. Out of a concern for fairness, or perhaps simply out of a desire to bring myself closer to other individuals, I involve myself in these situations. It will be with this same process in mind that I will attempt to redesign a boudoir in the Trace Gallery. On the day of the performance the audience will be invited to make its way from a fountain presented in the garden of the gallery to the naive exhibition in the boudoir.'

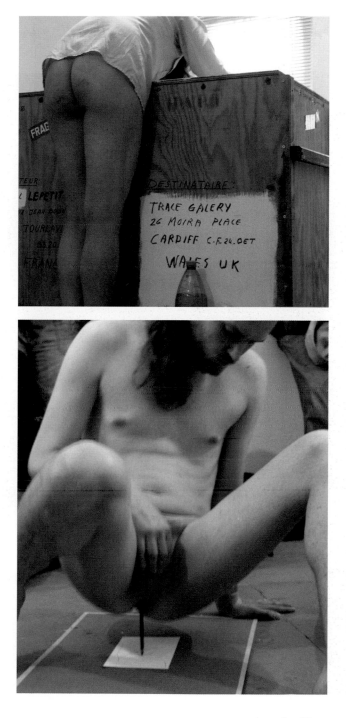

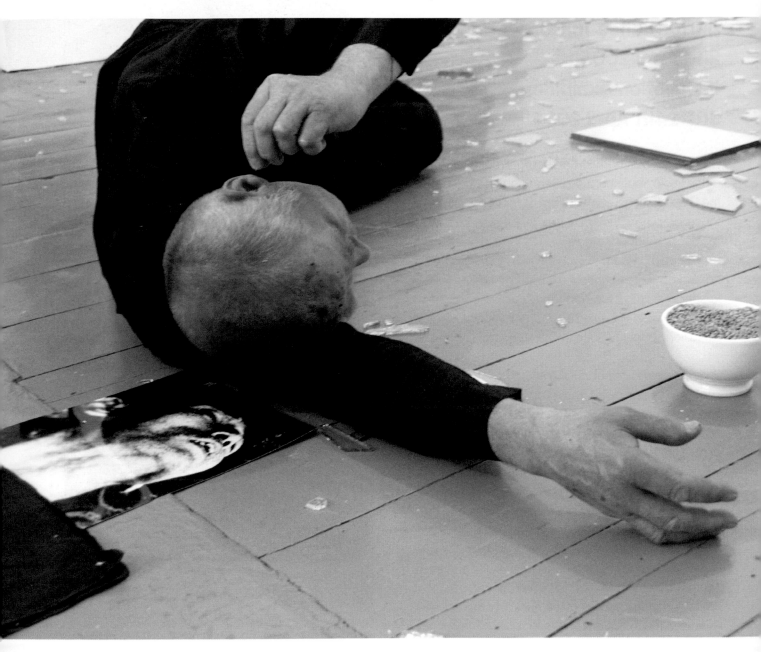

"Translation"

**performance 18:00
7th May 2005
installation exhibition
8th–29th May 2005**

Nature, Nature? Nature??? What a big word for a small consciousness. Performance. Performance?? What a small word for an endless consciousness. Boris Nieslony has dedicated his life to developing greater understanding of the philosophical, ethical, social, historical revolutionary and insurrectionary implications of performance art and to disseminating these findings as broadly as possible. He is a tireless and inspiring advocate of the art of performance living, lying in the encounter of meeting. He advocates the practice through organising and attending many artists' meetings internationally, publishing his and others' theoretical texts, archiving work and creating performance and installation works that forcibly confront an existential unease and an alchemical, visual poetry.

In 1985 Nieslony co-founded Black Market International, a collaborative meeting of performance artists, and in 1995 he founded Art Service Association, an agency connecting performance artists. Since 1995 he has also established a series of annual events in Germany, Permanent Performance Konferenz, designed to practically and theoretically investigate the possibilities of performance art.

<<ANNEX is an occasional series of live presentations that take place outside our regular programme. Work is made for one night only by international visiting artists who have made a significant contribution to the political concerns and implications of time based arts.

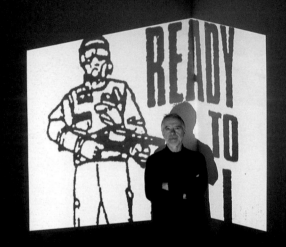

performance 18:00
28th February 2004

In August 1977 Uruguayan artist Clemente Padin was arrested by the military and imprisoned for protesting against the dictatorial governments of the infamous Latin American Condor Plan. 'Missing' (held and tortured) for three months, Padin was sentenced to four years imprisonment. Protest involving international artists' networks meant he was eventually freed after two years, but until 1985 Padin lived under constant surveillance and could not make art, leave the country or receive mail.

"My artistic production has been formulated, like many artists in my country, out of the experience of having artistic freedom denounced. This experience has meant that initially I worked in many ephemeral or non specific ways to enable free distribution of artistic actions. The evidence of the art is realised in certain moments as in performance art activity."

Padin makes use of distribution networks. In the seventies and eighties he used world wide postal networks to connect with artists. Now he also uses the internet. As a Professor of Linguistics at the University of Uruguay in Montevideo, he is concerned with many facets of intercommunication and the distribution of concepts and ideas. His work is formulated by interactions in many sites; the gallery, the street, virtual space: "I use any means necessary to produce art that creates dialogue and discussion about freedom and integrity."

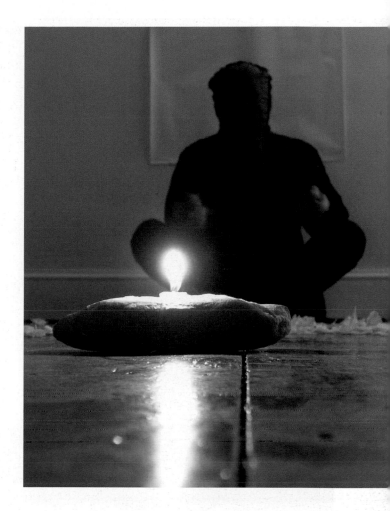

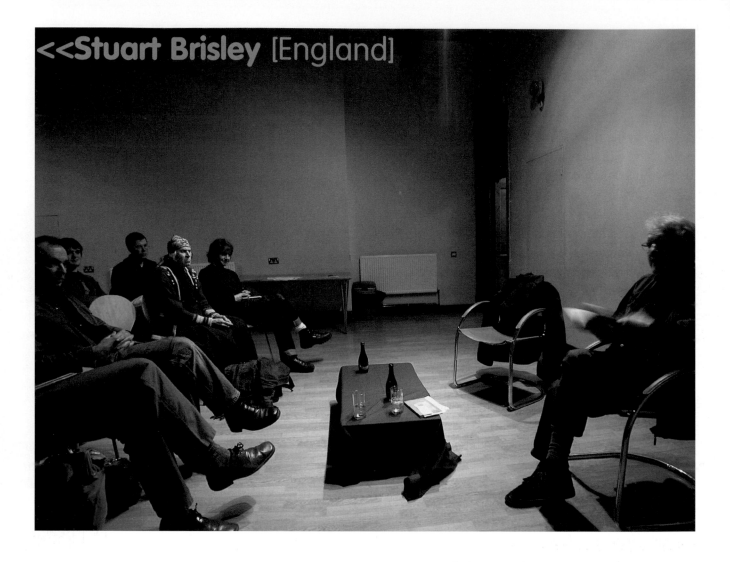

Performance reading: "Beyond reason: ordure"

Trace ANNEX at 2nd Wednesday Chapter Arts Centre, Cardiff 10th March 2004 19:00

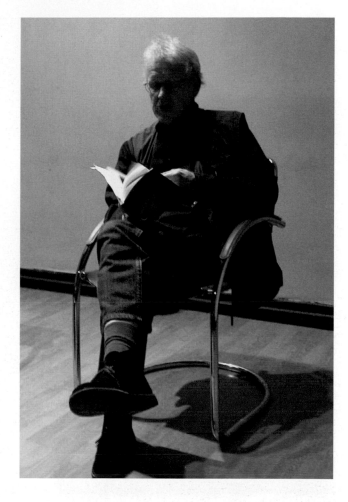

Stuart Brisley gave a performance reading from his new book 'Beyond Reason: Ordure' (Book Works) which explores work from his on-going project Ordure/Abfell [Ordure, dirt: anything unclean. Abfell, scrap, waste, remnant] which investigates the notion of what constitutes rubbish.

The book explores ordure in all its manifestations – shit, dirt, trash, excrement, waste, pus, pollution, dogma. The collection of ordure is the central object of the book.

The Curator, the Collector and the Artist are the main characters.

Why amass a collection of objects that defy rationality and economic worth?
Ordure is at the very nub of global capitalism – a nebulous but omnipresent stench that pervades everything. It is the final commodity.

<<Cosey Fanni Tutti [England]

"Selflessness 2 – Funereal action at Beachy Head"

17:00–19:00 28th May 2005

A video installation with documents of her recent private art 'actions'. "The main theme and aim of the series of 'Selflessness' live art actions is to address my feelings of alienation and displacement brought about by the 21st century western 'lifestyle'. But also to consider the consequences of superficiality – selflessness and hedonistic consumerism which distances people from one another ... simultaneously fusing everyone into a frenzied insatiable horde which makes only transient, superficial connections. The essence of the live art actions is to externalise the internalised in an improvised, unconsciously personalised symbolic way. To communicate on a level that refuses superficiality. Personal and symbolic objects are utilised as a means of ritual awakening to facilitate opening up and release from preconditioning and expectation.

Each site has symbolic, personal, cultural and geographical significance. Beachy Head is synonymous with the end of life, a notorious and deeply personalised place that we tend to depersonalise and disconnect from due to its renown as a suicide site. A bonding token from the live work is left in situ, a piece of myself. The existence of this token links the site with the nascence of the final work, thus reinforcing deeper connection."

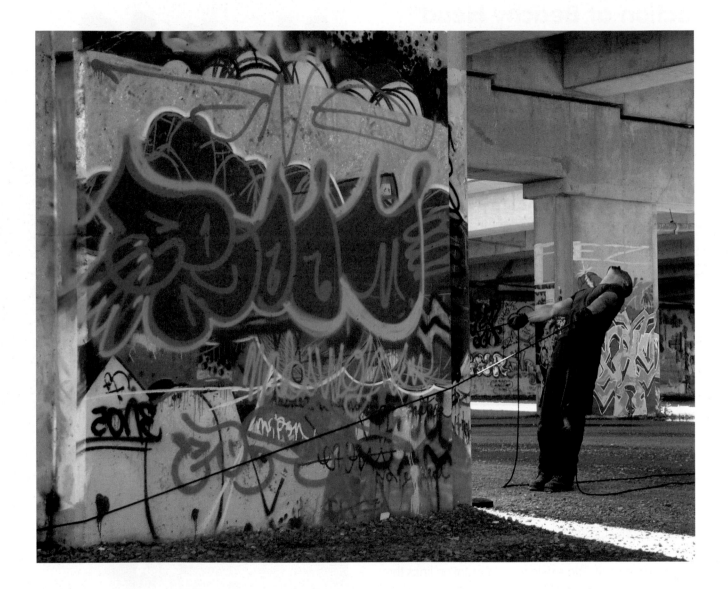

<<Trace facilitates networking and exchange as a core concern to further profile art originating from Wales. The organisation's international perspective is enhanced by these collateral projects to highlight a wider discourse concerning autonomous artists' initiatives.

collateral

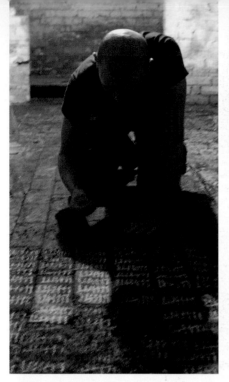
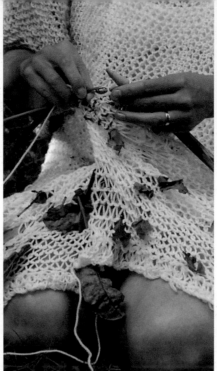

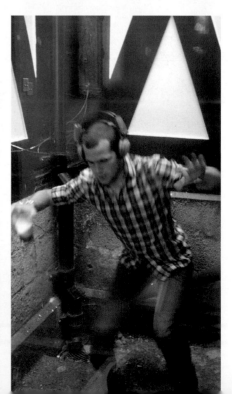

"Something for the weekend"

13:00–22:00 Bank Holiday
Monday August 26th 2002

A presentation of performance art at Gregynog Hall, Newtown, Powys, Mid-Wales.

Philip Babot
Matt Cook
Annie Harris
Odilia Jarman
Simon Mitchell
Richard Morgan
André Stitt
Duncan Sturrock

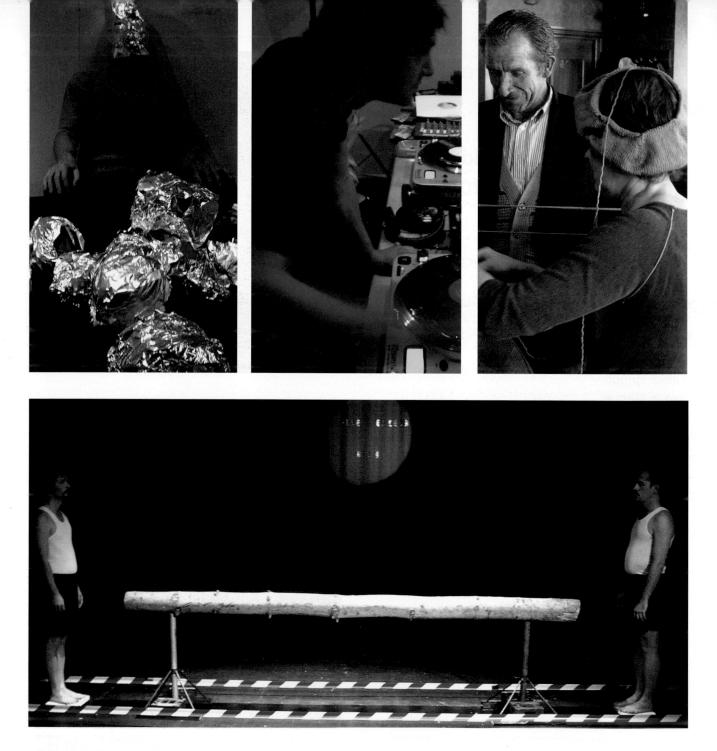

"Rhwnt"
Wales–Québec exchange

2003-2004

Rhwnt – 'between' in Welsh – was a significant encounter between artists, writers and teachers from different cultural backgrounds. Through contact and exchange, these practitioners put forward a collective affirmation of similarity. The unique identity of Wales, its language, colonial legacy and contentious economies of exchange embedded in its history have a significant correlation with Québec.

Rhwnt was a collaborative exchange between Trace, Installaction Artspace in Cardiff and Le Lieu, Centre en Art Actuel, in Québec. Both organisations were set up to explore intersections between artistic disciplines. Both artist-run centres locate their discourse within the dissemination of contemporary art practice that seeks to place emphasis on context, process, network and exchange. Their focus can be interpreted as primarily performative – to explore the previously unconsidered ways of 'thinking' and 'doing' offered by time based art and work that emerges from this activity – performance, installation, sonic and interactive arts.

André Stitt, artistic director of Trace; and Richard Martel, artistic director of Le Lieu, selected emerging artists from both communities to present live and installed work in two major events.

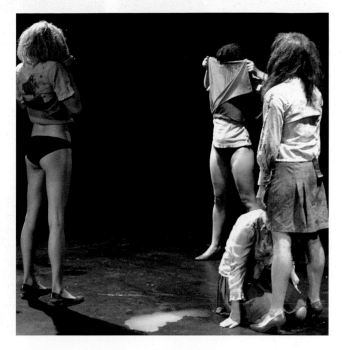

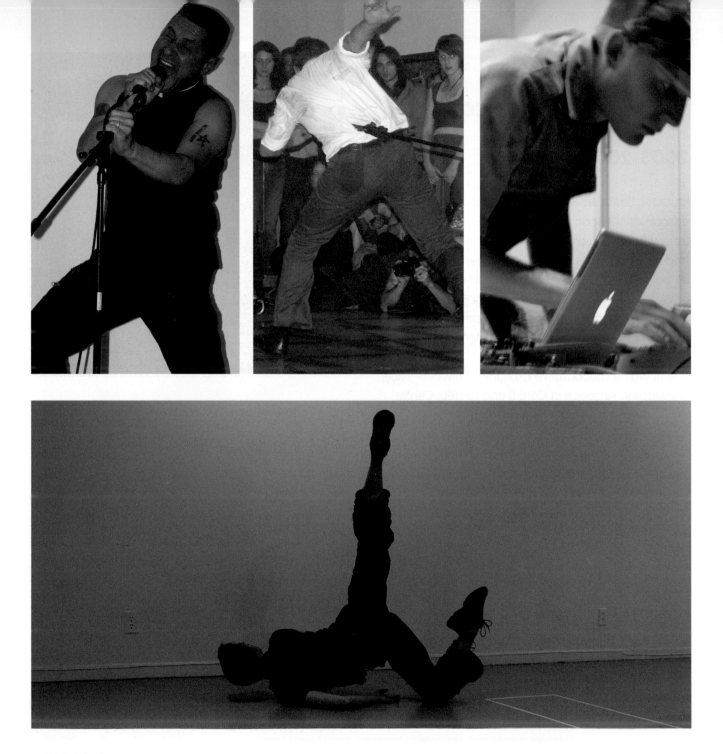

In October 2003 Québec artists presented at Trace, Chapter Arts Centre and specific sites in Cardiff. The event was augmented by two educational exchanges between Cardiff School of Art & Design, Concordia University, Montreal, and Cicoutimi University, Québec. A critic/writer from each city also took part to create a commentary on the event and to further contextualise the issues and debates that arose from the meetings.

In September 2004 a similar event took place in Québec representing Welsh artists. This included work at Le Lieu Centre en Art Actuel, sites throughout the city of Québec, Galerie Rouge and the Sequence Gallery in Chicoutimi. Education exchanges also occurred throughout 2003-2004.

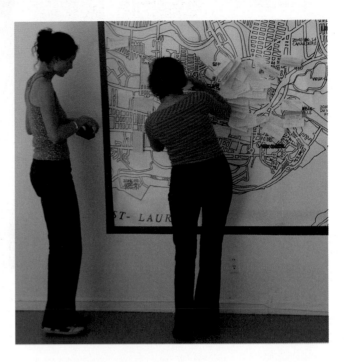

Quebec artists:
James Partaik
Les Fermières Obsédées
[Annie Baillargeon,
Melissa Charest,
Eugenie Cliche,
Catherine Plaisance]
Martin Dufrasne & Carl
Bouchard
Christian Messier
Claudine Cotton

Welsh artists:
Eddie Ladd
Paul Granjon
Phil Babot
Jennie Savage
Matt Cook
Simon Mitchell

Educational/Writers
Exchange:
Michael Le Chance
Guy Sioui Durand
Nathalie Perreault, Inter
Magazine

Educational/Writers
Exchange:
Heike Roms
André Stitt

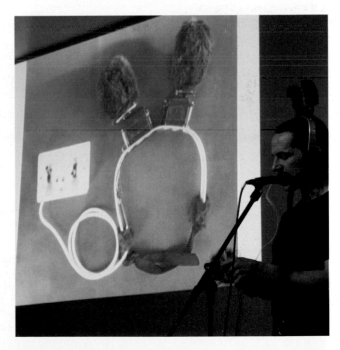

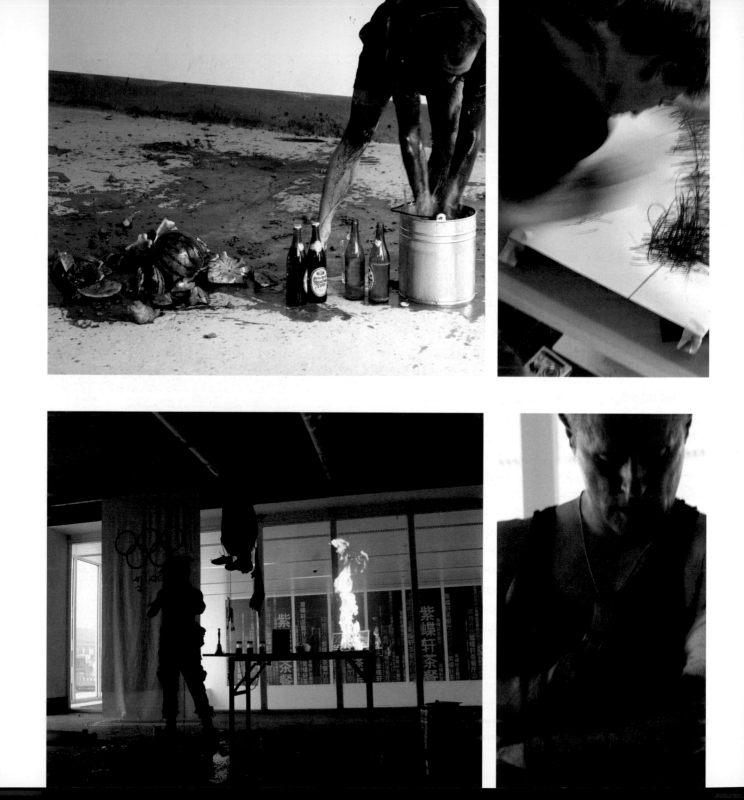

"Made In China"
2nd DaDoa Live Art Festival, Beijing, China

13th–17th July 2004

André Stitt; Phil Babot; Matt Cook; Simon Mitchell

The festival took place in the new Beijing business development area of Jianwai SOHO and featured artists from the UK along with contemporary Chinese performance and work from south-east Asia. Curator Shu Yang took great risks in presenting performance art in Beijing. Although there is a thriving underground arts culture, many of the subjects articulated by contemporary Chinese performance artists are taboo. The festival was closed down by the authorities on the second day, but after negotiation was allowed to continue under strict censorship: no nudity, no blood, no political subject matter. As these were central to the Welsh artists' work, their performances were programmed for the very end of the festival. The organisers were philosophical about the outcome. Shu Yang pointed out that he had been in police stations or under duress many times and was still willing to support this art. Indeed there was much debate about activities throughout south-east Asia under repressive regimes and circumstances. Many artists and curators attending felt that performance art could help create change.

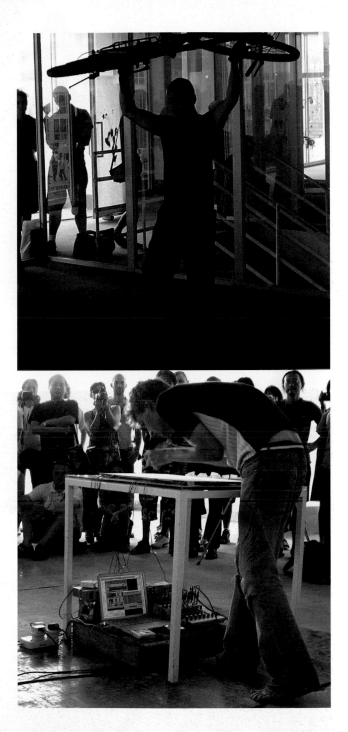

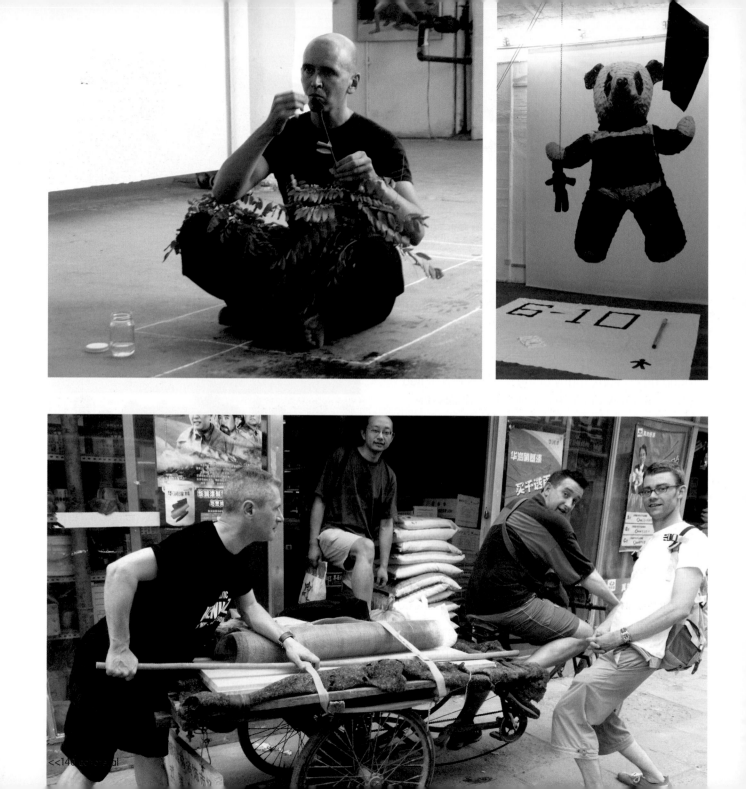

"Of contradiction"
Beijing New Arts Projects
Danshanzi Art District, Beijing

27th August–8th September 2005

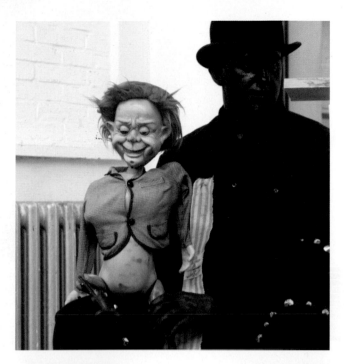

"Every wakeful step, every mindful act, is the direct path to awakening. Wherever you go, there you are." – Buddhist text

"Contradiction and struggle are universal and absolute, but the methods of resolving contradiction, that is, the forms of struggle, differ according to the differences in the nature of contradiction." – Chairman Mao Tse-Tung, August 1937, *Selected Works*, Vol.1 p.344

Selected artists André Stitt, Phil Babot, Lee Hassall and Paul Hurley worked for three weeks each from a studio base at Beijing New Art Projects. During this period the artists explored, researched, carried out movements, interventions, actions, collecting/ collating psycho-geographical data,made, constructed, installed, performed, talked, exchanged and reconstructed, based on the theme 'contradiction'. The residency included a live collaborative programme with Chinese artists, artists' meetings, talks, a conference and an installation exhibition.

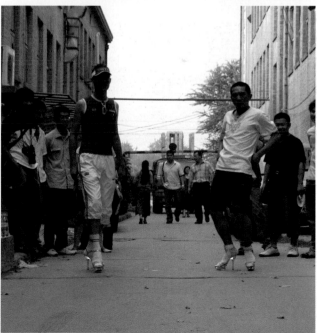

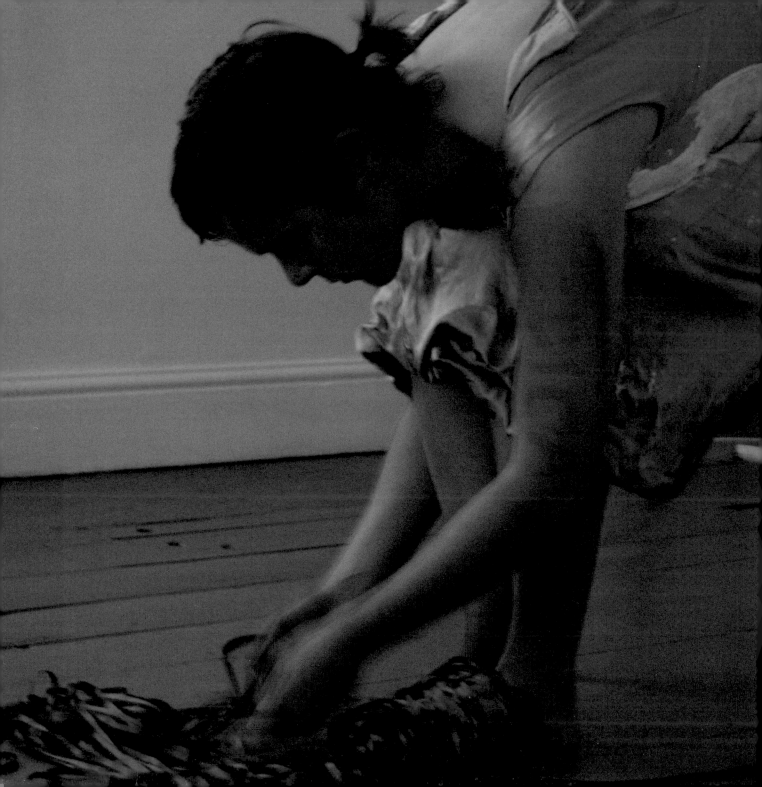

<<Julie Bacon

Beyond histories

Trace and the re-makings of the present

Preamble: Dispersal

One way of commenting on a long term project, or an institution, is to go over the successive events that have taken place under its auspices, charting a cumulative effect, from which you reckon a sum total; a version of what the whole thing amounts to. A body is translated, eyes that have seen, tongues that have said, hands that have written and gestured. The body is conceived through a grammar of things unearthed, through ways of deciphering and encoding, the elaboration of perspectives, treatises, anecdotes and hearsay.

In this text about the Trace gallery, on the occasion of its fifth anniversary, I am not so concerned with 'totalling' – with an historical stocktaking of Trace. Trace, in its presentation of ephemeral art works has, arguably, little to do with a logic of accumulation. What I am thinking about here is this: what is Trace *dispersing* in the city? How do the meetings and departures that take place there figure in relation to encounters that other spaces, and their terms of entry and passage, afford?

Trace presents art works that immediate relations through which living conditions are unfolding – that is, impacting *upon* us and being effected *by* us – by creating investigative and discursive space. For the time being, this space that I attribute to the art works might broadly be said to arise as artists go to Trace and make *arrangements*[1]. Through placement and displacement over time, processes of ordering experience, and the values that at once inform it and are created by it, as well as the systems that are derived afterwards, are all brought to bear. By this I mean that it is experienced as an *event* in a time and a place.

The condition that there is an action, and a remainder in the installations presented at Trace, and that this *act-archiving*[2] is constantly remade, invites us to think further about how our immediate encounters carry our aspirations, foster our memories and are shot through with our histories. This is in the recognition that we are bodies *absorbing and constituting* the environment. By looking at dispersal, I wish to focus on what Trace contributes to the realising of presence as bound in our grasp of previous moments. It contributes in the here and now that is an *ever-dispersing present*, but which may leave a mark and be marked, within a city whose day to day life also takes place through spaces that attune[3] the present by modes of containing: reproducing, documenting, recording, gathering selecting, surveilling, capturing, storing, judging, monitoring, interpreting.

I am proposing that Trace not be assessed materially in terms of a residue from which to extract a chronology, but dynamically. As much by what is less there, uncertain, and changing, as by the realm of the known, when that is taken to mean 'that which is held'[4]. Given this intention, it is important to remember the simultaneous comings and goings across space and through rooms; to conjure up the living room gallery, the passage of artists, and temporary existence of arrangements and abandoned materials, that is the wake of their presence[5]. At the outset, it is worth re-collecting the dissemination of performance *in* people *in* installations *in* the home *within* the city, *at the same time* as the schedules of deliveries (goods, correspondence and births), the pattern of burials (landfill sites, whispers and funerals), the force of combustion (hospital incinerators, automobiles and public transport), the premise of incarceration (pet shops, prisons and archives), the frequency of emissions (televisual and digital broadcasts, bodily secretions) and others...

With this sense of a city as a living arrangement (and so a processual entity, not a map, or a framework), I begin this discussion of how the art works in the Trace gallery, and the premises itself, disperse aspects in the city – that is, act in many directions in the same time[6] – with a reminder of an event that took place in another city, many decades ago. This foregrounds the way that the past escapes definition, highlights disappearance and loss as a force in any event and so questions

representation as a means of accessing the past.

In the city, the museum space is testament to the drive to resist loss, to present accumulation as a strategy that gives sense to experience and manifests knowledge. More than that, it is a mode of remembering that promotes living as an act of taking on more and more, filtering, but ultimately increasing, that is progressing. I choose the museum as a site in the city with which to contrast Trace because, on the surface, the museum's logic of accumulation is quite unlike the ephemeral premise of Trace. Not only are the surfaces different, but the ways of evaluating the past, the types of memory and the sense of the present that stem from museum's central logic[7] and Trace's premises differ. Although they clearly deal with the same things, if it is the body's experience, material conditions, and states of perception and knowledge that are at stake.

I focus on the operation and the values of the museum – which devotes time to the conservation of objects – and the conditions in Trace, where emphasis is placed on action that folds into an archival situation that is temporary. I highlight the issue of theory and practice in the museum, the relationship between the management of space, the handling of objects and ideology, and note how forms of ordering impact on the experiencing of time. I then introduce the praxis of Stuart Brisley, and outline how his *Abfell* project, which visited Trace, explores types of object-handling that confer the status of artefact on materials and challenges our perception of waste.

Brisley's work prompts us to think about what we are taught about the past through the object and its preservation. I note how this preservation in the museum itself functions as a defining interpretation whose resistance to change expresses a sanitised version of living. I go on to consider the role of *Abfell* in Brisley's larger project, the UK Museum of Ordure, and examine the reality of decay and loss in relation to the dynamic of creation/destruction. This, I suggest, is a premise of Trace and installation art, with reference to

Gustav Metzger's proposal of 'auto-destructive art'. Re-making appears as a means of *negotiating* a present that reverberates the past, but does not hold on to it.

I explain the dynamics of presence and absence in installaction, commenting on how time based work invokes the processes of forgetting/remembering. I emphasise how praxis – notably that of phenomeno-logical enquiry – opens up the shifting range of experience beyond fixed relations described by dialectics. I assess how the physical conditions in Trace art works express proximity and porosity in the city, with reference to Roddy Hunter's work; then consider further how we experience time based, ephemeral work, commenting on the ways in which process disrupts orthodoxy. I propose that this demonstrates an opening up of research, as in the work of the High Heel Sisters at Trace. Sketches of the work of Jimmie Durham and Louise Liliefeldt further point to the investigation of states of belonging, and ascribing names.

I examine how art works in Trace shift our perceptions of scale, challenge certainty, and temp-orarily precipitate the viewer into situations where the body and the mass of its interactions is felt, as in the work of Istvan Kantor, Julie Andrée T., Morgan O'Hara and Jamie McMurry. I conclude by studying how Trace disperses the economy of the home and archive into other ideas of shelter, and ruptures a cityscape of surveillance by breaking down private/public barriers.

Some of the discussion comments on the conditions that artists working with installation, or performance-installation, in general create, and are not a specific feature of the way that Trace operates. However, two points should be made here about installation at Trace: firstly, the gallery is exceptional in that it focuses exclusively on this way of making art; secondly, the conditions of the work are inflected, to varying degrees by the physical and psychic impressions of being in a gallery, in a home, in a city. It is not a question of 'how was it there at that time?', but 'how can we be in the city?' So, I wish to think again about Trace's exploration

of "previously untried ways of thinking and doing offered by time based art and work that emerges from this field"[8].

Mass dis-appearance: representation, museums and the event of memory

In a previous text[9], I described my journey to get to Trace, with a view to putting Trace in context, giving a sense of how the individual's passage through the landscape of the city bleeds into the passage of gestures and impressions arising in the art works. At the time of writing, another city looms large, not one to which I am heading, or have been, but one that approaches like a phantom through a surge of televisual images and radio reports resuscitated from archives, and drawn into commentaries. It is also the 60th anniversary of the dropping of the atomic bomb on Hiroshima. What followed in split seconds and decades, was the disintegration of living and inorganic matter, and of the myth of progress. Tens of thousands of homes collapsed. In some cases, shadows of the victims formed the only trace of their vaporised bodies, of evaporated flesh and bone. One pauses to imagine the energy that it takes to disintegrate bone. It happened, and this happening is confirmed by a mass disappearance.

To account for disappearance, archaeology draws upon buried remains. But what if all you left was a shadow, and then this shadow itself dissolved. Where do you go, what form of history, or memory even, can be made? If this event was burnt on the optic nerve, or skin, you might remember with the pain of actual bodily injury, be reminded as you wash yourself or make love. But otherwise? A monument? A museum? As for

documentary evidence, that is created in controlled conditions in the aftermath. No photographs survive of the impact at the site – chemicals and papers evaporate before bones. Some documents of destruction remain (the armed forces were filming from afar) but the form of the mushroom cloud they record for their analysis and the viewers back home is an abstraction – a removal from context – of the bodies and buildings and elements it contains.

Hiroshima as a site of mass destruction is a potent reminder that the issue of representation, and the matter of memory comes up at the site of loss; of something slipping away, suddenly disappearing, being gone *before you know it*.

Yet this subsidence is also something everyday. How, if at all, can we gain access to the past? The museum is presented to us a place for such an encounter. In 'Museums; Theory, Practice and Illusion', Danielle Rice[10] points out that writers often criticise the museum as an ideological vessel rather than a place:

> Although the past two decades have seen a substantial increase in museological theory, the relationship between theory and practice is irrelevant to most theorists who see museums primarily as ideological symbols of the power relationships in today's culture... On the other hand... most museum practice continues to be too deeply rooted in the politics of competing interests...[11]

In the theory of which she talks, critics draw upon aspects of the history of the museum to propose that it embodies hierarchies not only scientifically, with regards to the classification of specimens, but also culturally, with regards to the typology of peoples, and the authority of one – the interpreters – over the others – the interpreted. The historical context of the ideas that underpinned the beginnings of collections/archives is used to make a case that the role of the institution is problematic today, because of the relationship between inscription – entry into a recorded form – and prescription – the setting out of

the terms on which we live now.[12]

It is interesting that Rice should feel the world of theory and practice are at odds, and it is true that abstract and remote analyses of museums that seem to defy any place do exist. Essentially, though, regardless of stylistic shortcomings in critiques, one has to observe that ideas and actions are much more interwoven and interdependent than the separation of so-called theory from practice will allow. We have conjured up the divide between theory and practice, and uninteresting convolutions arise in the face of trying to lay this alienation to some imagined rest[13].

When we return to the actual place of the museum, whether behind the scenes or in public access areas, we observe that practical ways of handling objects and documents within an institution cannot in fact be divorced from the ideological. So the history of ideas is embedded in the history of objects and these bear witness to our forms of ordering, and so our aspirations of power and agency in the world. Ways of encountering museums, through the types of access afforded and the managing of movement – that is the handling of people – these are not separate from the experience we are designed to have, and fold into the content of values and meanings that are communicated.

That there is prioritisation of one thing over another and exegesis in the museum is not the issue; rather that it fails to embrace its own expressivity, or ideology, that is: "a society's unconscious tailoring of criteria of objectivity to fit its own interests"[14]. And so

> The history of modernity[15] becomes the histories of ideology, power and the unconscious ... histories of the latent selfish content of a culture's surface expostulations of honesty and good faith.

The very politics of competing interests that, ironically, Rice sees as defining this separate part of museum life called practice, is that same surface of interest that may be broached by critical texts[16]. There are differences between a text that discusses museums and a visit to a museum, but there are also similarities. Both the text and the space convey how forms of ordering come forcefully to us as 'reasonable' – morally or scientifically – thereby legitimising some actions and expressions, and discrediting others.[17]

These forms of ordering orchestrate wonder, but also diminish the subjects. Making the artefact sound better has a reciprocal reduction effect, creating an overall vertigo-like distancing. The spectacle of unattainable wealth, and unattainable endurance, inevitably seems most impressive and imposing to the poor. Whilst we trundle round the mill of human experience, framed in epochs – Byzantium, Antiquity, Renaissance, the Space Age... and so forth – what is our experience of time in the museum? The chronology of narratives and the objects that give them substance stand in for time. Where time is most tangible is perhaps in the duration of the attention span, along with, perhaps, the functional time of the museum day – our sense of people working around us. Through the generally restrained and particularly funereal ambience of the museum, we are not actual, temporal subjects, rather we insert ourselves into particular conceptual scenarios, based on one type of hermeneutic authority or another; History or Histories. It is useful to recall William Blake's suggestion that

> all our categories of authority and reality are human constructions, poetic figures answering to the imagination in each one of us.[18]

In contrast to being taken out of time, the framework of ideas and the matter of handling collapse into process in Trace. The artist Stuart Brisley explores the relationship between designating material value, ordering and maintaining authority. At the gallery in January 2002, he presented 'Shopping for Shit', a work from his on-going project Ordure/Abfell[19], which investigates the constitution of rubbish. In another

lecture that formed part of the Abfell body of work[20], I witnessed an amusing, and not unconvincing account, by Brisley of the curatorial tactic of elevating objects in order to inscribe them with importance, to give them authority. Wielding perhaps some of the same historicised turds as in Trace – the exemplification of the ready supply of shit giving rise to a new sense of permanently collecting – we were treated to a demonstration of how the simple matter of scale – the physical proportions through which things are represented to us – can be an expression of power because it holds the viewer and the object or building in tension with each other, and because of the impression of centre and periphery that this creates[21].

The didactic mode with which Brisley explains the significance of the turds is interesting when we recall that access to the past, in the museum, is presented as a learning experience. We are the pupil – something of which we are in awe – which subdues us, almost. The radical nature of the past, the reality of ruptures, the interplay of power relations and material conditions that inflects how we are viewing, not just what we are viewing – are treated as accessories. The preservation needs of the accessories (the bits and pieces that living spawns) end up prescribing the terms on which it is reasonable to remember the events: the cart indeed goes before the horse; the object before the animal; the artefact before the human. When the object's needs take precedence, a sanitary version of living conditions stands in for the messiness of existence. Challenges may then be excluded on any number of grounds: the cipher of health and safety; the protection of the museum's family audience; the need to be 'neutral'.

This sanitised, object-based past is challenged by Brisley's habit of collecting fossilised turds. Through this dirty habit he condenses something of the gist of the economic order defined by expansion, surplus, and so waste. This curatorial project is part of the UK Museum of Ordure (UKMO), a digital online archive decomposed of images of objects that are contributed by people who scan material and donate them to the archive, where they are subject to "occasional bouts of a viral-like infection causing transformations in the holdings"[22]. As is pointed out by another artist who has appeared in Trace, Roddy Hunter[23],

> UKMO is situated both within and as a contemporary mode of production where the effects of decay and duration on the artefacts which populate our contemporary world (commodities in effect) are induced through the deliberate stimulation of 'bit rot': an unmanageable process of corruption that slowly deforms and disables its data.[24]

This museum has done the 'unthinkable', remembered that which was forgotten in order to sustain the preservation needs of the object – by identifying and locating the act of destruction with that of creation.

> Brisley's initial conception of UKMO is... concerned... with the hegemonic ideology of reproduction and of hegemonic reproduction itself in all its eventual actuality. These concerns fear a totalising social and political hegemony that considers its excreta in all forms to be both its evidence and its production... UKMO is a matrix of value creation through 'détournement'.[25]

In so doing, the museum re-subjects the past, conventionally exemplified by the state of the object at a given, anterior time, to the messy existence of living. The past cannot be stabilised as a metaphor and narrative extracted from the artefact, because the artefact does not remain as such.

The choice of some people to scan body parts for donation – as images – to UKMO, is interesting, as this emphasises the recollection of our own condition of expiring creation[26]. It is significant also that mummies, of the Egyptian kind, are usually one of the greatest attractions in the museum: we gaze on at the body, the fantasy of death as sleep, a model of retarded decay, an icon to the desire to transcend time. Perhaps also, as Hunter suggests:

When we marvel in front of Museum displays we are possibly marvelling most of all at an object that has survived the processes of obsolescence that we cannot.

This attraction is also, perhaps, an echo of the memory, being shouted in canyons somewhere, of the somnambulism of culture.

Presence, absence and the re-collection of space

The invocation of intertwined destruction and creation that is an aspect of Brisley's work, characterises the premise of the Trace gallery. Artist upon artist creates and then their work is de-composed, dismantled, disappeared. To come back to the question of how we can access the past, to this matter of representation/ memory occurring at the site of loss, we might begin to answer, through Trace, *by engaging in the unfolding power relations of recurrent now*. This now is not external to us, a city being regenerated over there (from where we can adopt a position or outlook, be drawn like stick people into the design model). It is an economy to which we are contributing, in which our presence, and our absence at (appropriate) times is required, our engagement and disengagement demanded, again and again. At the site of loss in the installation art methodology, appears *the imperative – the incitement – of a remembering linked to a remaking*. In this light, the remaking, the *ongoing discontinuity*, that takes place at Trace is different from the conception of trace – as expressed in institutions such as the museum. Here, 'trace' is an action of drawing a chronology of events to successfully make a common sense surface of history. The art projects disperse ideas, images, energy or actions, to create an understanding of 'trace' as a 'temporary re-collecting of fragments'. The variety of artists and approaches to making installation at Trace

intervene to create openings, rather than amounting to any kind of whole. The drive to consistency, which is inevitably ideological, recedes into the difference.

Through his manifesto of auto-destructive art,[27] the artist Gustav Metzger articulated the scale of destruction implicit in modern creation.[28] His later work *Damaged-nature auto-destructive art*[29] outlines how the construction of civilisation defends us 'against nature': entry into the civilised state brings losses too.[30] If museum history tends to act as a buffer from this reminder – where the permanent collection reassures us against the vacuum,[31] the art projects at Trace actualise our experience of loss – slippage, indistinctness and disappearance – as mutual with manifestations of our visions, actions and aspirations.

This mutuality is a matter of the dynamics of presence and absence; for one thing to become present, another authority recedes, making space as it were.[32] This is not a geometric agreement, but precisely a shaping of perception beyond the polarity of positive image, and negative, to use photographic terms[33] reminding us of the relationship between forces, and the abstraction of frontiers. Installation art offers conditions to foreground this: the installation is not the negative of the performance, we cannot reprint it from that point, nor can the inverse procedure be carried out; we do not witness all the arrangements or a finality, our own presence and absence also marks out the space, as we come and go with our own eyes and in the eyes of others.

This understanding prompts a different view of what it is to be present somewhere, and one's potential agency. Different conditions of space and time foster different recollections, i.e. mental and physical associations.[34] They remind us of memory not only as a bank of information, but as an action and a duration. In his book *Culture As Praxis*,[35] the sociologist Zygmunt Bauman suggests that we proceed not so much by accumulation as by a process of forgetting and remembering. This points to the shortcoming of

George Santayana's remark that 'those who cannot remember the past are condemned to repeat it...'[36] It is precisely because we forget, because stable storage is so relative to quantity[37], that the way that memory takes place, or doesn't take place, is as important as the invocation to remember and the content of the memory itself. Remembering is not a stable pastime, reposing in knowledge or a monument, as we may have forgotten the power relations that enable any idea of what the structure might mean.[38] Spaces that make clearings in accumulations, and time for the encounter – in this case installactions – can intensify memory as an event, of coming into and out of view and being.

As Metzger intervenes in monopolistic and distanced views of history, as Brisley intervenes in the gargantuan economic order of consumption, and fragments the repository of the museum, so Trace is one space, amongst others – sometimes alleyways, sometimes arcades, at times the unreformed areas of urbanity – that interrupt the totalising of the city, in the sense of homogeneous, or levelled textures. In contrast to the discourse of theory and practice (to approaching something as conceptual or logistical), Trace fosters a praxis of the body in space, an enquiry that shifts the placing of objects in historical narratives in the museum. It brings into focus the dynamic of subject-object relations, and the exploration of intersubjectivity: the observation of a woman, slicing skin, letting blood, as in the work of Kira O'Reilly;[39] placing images of the deceased others over the artist's face, as in the work of Boris Nieslony.[40] Here photographic paper on flesh resonates beyond the silent death masks in the museum. Beyond the object, it is the encounter, meaningful and (e)strange(d) associations, that matter.

In contrast to the viewing of consumable images (a diet of executions and catastrophes at tea-time, so that people ingest them with the supper that fills the vacuum created by the day's labour) the intimate but public space of the gallery does not privilege such detached encounter. Our sense of things moving about is accentuated: things absorbed, spilled, blackening, alleviating; ambiences thickening and thinning. We are aware of the porosity of living conditions, which the glass screen of the television and the vitrine seem to contain; we are unprotected in some senses. In contrast to the dissociation of the management of museum space from the contents, we are acutely aware of the parameters of our movement in the living-room gallery, and this awareness, and the way that the space and artist afford circulation, or otherwise, appears as part of the work.

There is proximity, literally, in the confined space, maintaining a distance, of safe viewing or another, is barely tenable in the performance, when the largest number congregate. Our bodies take up space, and this basis informs how we gauge what is happening to other bodies, objects and materials. When and if we return alone, stripped of the congregation, we can experience to another degree the invisible layer of past presence, the skein[41] of the act-archive. These relations of proximity and porosity are essential to the possibility of there being different experiences and knowledge in the city, to recall the question posed at the introduction – how can we be in the city? The art works resonate with our living conditions, the production and decay of material, the abandonings and discoveries, the hidden and the (over) exposed, the foreground and the background, the out of sight and mind.

The work of Roddy Hunter at Trace[42] creates conditions for the immediate space of the gallery and the street in Cardiff, and a past experience of another place, to become porous:

> I rolled up the blinds and opened the windows to let the sound from the inside meet the noise from the outside... to go back to the lightbox. There were... photographic slides I'd taken of an abandoned housing project for phosphorous miners and their families in Zhanatas, Kazakhstan... inhabitants [had] protested against job losses in temperatures of -10 degrees or colder. Over 100 began a hunger strike. I found out about this on the internet after returning from

Kazakhstan, nobody told me about this when I was there. Although my visit there was recent, I can never immediately recall... when I went to... that place, Zhanatas... there's an impossible subject. The artist as an ethnographer can yield villainous consequences and when the artist ethnographises him or herself you start to drown in a psycho-cultural feedback loop of self-destructive proportions.[43]

There is an emphasis on the non-objectification of enquiry, and this way of attempting investigative and discursive space, or merely engaging with phenomena, does not, as in the sciences, abstract the enquirer. In the phenomenological approaches that nourish much work at Trace, the artist does not necessarily 'know'. In this he/she differs from the requirement of most enquiries, experiments and explorations – that those conducting the work are apart from the focus of their study, and emerge in a position of knowing in relation to it. The process of making (of conducting materials), remains a negotiation, that of not entirely being in control, but re-adjusting one's position, manoeuvring with impressions and transformations that take place, through whatever is brought into the field of that encounter. In Trace, the methodology of collecting and dispersing is temporal and site-specific, rather than referring to time and claiming universality, and is not required to oppose or offset uncertainty.

Juxtaposition, glimpse and accident feature as moments tailoring our perception, in the installation, as much as elaborate formal layouts. Things of uncommon orders (which did not have a reason to appear together) may be brought together, and not upon the understanding that a conclusion must be drawn. Time based work allows for the sense of a critical mass to emerge, but also spills over into disappearance; when duration is extended, we feel the ebb and flow that compartmentalising time restrains. This is the sensing of time not as a law, or a threat, but as shifting order of things, the time of a wave mounting and crashing onto a shoreline, only to be re-formed. The time of a body in a room, of intentions, witness

Dan McKereghan – At Sea – "Meditating on the themes of wandering, discovery and isolation".[44] There is pleasure in changing speed, in the slowing and quickening of thoughts and hands and breaths.

Undoing orthodoxies: legitimacy, belonging and processes of precipitation and dissolution

Clearly, we have learned ways of encountering installations too – and received attitudes to art, but the interpretative space of the work is not controlled by slogans, textboards, screens, security guards, cameras and the like.[45] In this absence, different fields of significance morph, at once heightening and stretching time, with all that this means for the composition of perception from layers of experience. In fact, as soon as we are taken out of the functional mode of operating, into a space where time is activated – because it is not a given duration associated with a routine or habit – phenomena latent in our mind's eye can come to the fore; the impact of things converging, disappearing and colliding in places recently, some time past, lived and imagined, is touched upon.

Undoing orthodoxies depends on the de-internalisation of the legitimacy to which they lay claim[46] – the powerfully constructed situation whereby something cultivated seems 'naturally so', and therefore authentic, normal, reasonable. So whilst we are clearly not in a space which exists independently of the drive to conform (that is channel diverse stimuli into pre-set stations, a task which we learn to perform from such an early age) it might also be said that the work tends to upset something of its own emergent orthodoxy – any

sense of its own accepted practice, custom or belief – through the risk that underpins it: of presenting structuring and re-structuring (not the finished version); the unknown moment when something falls or stands quite still; the openness of its own order. In its method, not as a subject or theme for representation, it seems to me that installaction invokes the dynamic relationship between control and breakdown, where this breakdown is not seen as negative, something to be resisted, but is acknowledged as that which is at once taking place when any order is imposed.

The work does not lay claim to territory physically or conceptually, it takes place through a process of marking out events, only for those marks to give way. As such the praxis makes possible a deterritorialisation of body and thoughts and objects from the boundaries in which they are held. The intensified forces and relationships that appear do not assume a longevity, though they may endure. There is not an externalised position of authority to protect, or adhere to; authority operates in terms of an intent to decentre the status of things and identity. The proposition of finding out, of dispersing the act of research in the city is demonstrated by the work of the High Heel Sisters, at Trace in Season 5, March 2005. As their statement explained:

> During a preparation work-week on site, in Cardiff, up until the opening of the exhibition HHS will make a series of activities in public spaces. The purpose of the actions are to create experiences of the city's ongoing ideological negotiations and of our self in relation to the ongoing discourse. Some of the results of this research, or experiences gathered, in the form of texts, video documentations etc., will be shown at Trace, blended with traces left from the opening performance.[47]

If the physical impact of our surroundings on mental space (our frames of mind) is accentuated, so our own capacity to shape our material experience through acts of the imagination resurges. This constitutes a change from operating the city as it is given (with established forms of interaction in given ambiences) to regarding one's movement in the city as intentional, that is, to reiterate, as a negotiation.[48]

The exploration of states of belonging, and un-belonging by challenging nomenclature, is a recurrent theme at Trace, as seen in the work of Jimmie Durham:[49]

> His work at Trace investigates recurrent themes in relation to the USA and issues of colonisation and imperialism... His work in general, be it performance, wall-based, sculptural, and ersatz ethnographic displays deliver ironic assaults on the colonising procedures of western culture and weave a complex thread of puns, poetry and political.[50]

The work of Louise Liliefeldt[51] approaches the re-making of the present, by re-intervening in historical discourse, and also revisiting her own autobiography:

> From South Africa and based in Toronto, Louise Liliefeldt's work is predominately concerned with the politics of identity as it intersects with issues of gender and race. Psychologically Cage is a further development into a piece I performed in 1999 in Québec City giving expression to a traumatic experience. Physically I am attempting to rectify a performance gone wrong.[52]

To whatever degree this rectification can take place, this approach sets the challenge of re-entering the dynamic of a specific memory, of a re-embodiment, unlike a re-enactment or a representation where historical surfaces are emphasised over the depth of intent, which remains accessible to us, and is something that we can draw upon at a later date.

The scope and openings that these methodologies seek, point to the role of research in the installaction process, and indeed the Trace gallery as a place for 'close, careful study'. This performance of research into actions, events and remains, challenges stabilised frameworks of knowing, and, stepping back, the desire for them, their use, and application. But the work does not report back to a guardian paradigm – of laws governing procedures, of prescribed aims and

objectives) – and as such the negotiation and experimentation constitutes an anarchic process, where 'anarch' means 'without guardian', not without order, but a matter of 'different forms of order'. We might talk of an 'embodied epistemology' within the praxis of the art work. A re-location of site, and an integration of subject-object relations in that discipline defined as the 'theory of knowledge, especially with regards to its methods and validation'.

In the statement about Trace, André Stitt points to "previously untried ways of thinking and doing offered by time based art". Whether they are previously untried in the literal sense of a chronology (because such a chronology is doubtful), the art works take place through the expression and conception of power relations as they are manifest in our times, then at each moment we perform such research, we are potentially, breaching the veneer of specialist, disciplinary enquiry – with an interdisciplinary, ephemeral and unauthoritative re-making of living conditions.

This embodied epistemology (of the witnessing, researching body) can underpin a strategy of de-alienation, where alienation is that sense of being scaled out of things, subject to a proportioning of forces, its locus of power elsewhere. Cosey Fanni Tutti[53] explains:

> The main theme and aim of the series of 'Selflessness' live art actions is to address my feelings of alienation and displacement brought about by the twenty-first-century Western 'lifestyle'. But also to consider the consequences of superficiality – selflessness and hedonistic consumerism which distances people from one another in the true sense while simultaneously fusing everyone into a frenzied insatiable horde which makes only transient, superficial connections.[54]

This fusing may be regarded as a veneer generated by the desperate confidence of spectacular living[55]. The apparent necessity of being crowded in isolation is challenged; the making of the art work does generate that coming together on some terms, not those of transcendence into a permanent state of bonding, but the advancement of the principal of an engagement with each other.

In an age of superlatives, hyper-taxonomy, and the spectacular re-presentation of everyday life as an edited pastiche of itself (where the complexity of our relationships is fed back to us puppet-like, and synthetic) uncertainty has a humanising impact. Ambiguity as a force in the installaction – work that is finished and unfinished – reminds us of the thin web of classification.[56] In the absenting of the haunting image of a (re)solution, we are precipitated into other states of being. The scale of precipitation is humanising – as Julie Andrée T. says of her work, Unexpected Thought:[57]

> when actions such as walking, talking and making sound are performed within a context where a clear imprint of action is left within a space in which it was produced, one can see a real cohesive relationship between action and matter. As if the echoing of human gesture possesses a valuable and sensitive continuum, even within the smallest of traces.[58]

This cohesive relationship expresses the continuum of the conditions of rupture and meeting. Force appears as a factor of our precipitation out of modern solutions whether: through the production of graphite marks on paper or walls through the weight of our gestures, that is the live contact between eye and subject and between pencil and paper in the work of Morgan O'Hara;[59] through drawing on a well of volition as in the work of Jamie McMurry, who states the following about his focus at Trace:[60]

> The immediacy of the activity – The compulsion that states without statement – The range and power of the action – Performance reluctantly declares itself alone by choice and Proudly declares itself family, unintentionally.[61]

In being dispersed and convergent, alone and family at the same time, so belonging is not definitive, it is an ongoing articulation; that which seems to claim us, can be disowned, shed.

The work of Istvan Kantor[62] carries this charging of space into states of climax; the impact of industrial and technological furniture and apparatus is re-located:

Utilising filing cabinets with live action, sound and video 'Machinery' explores the socio-mechanical bodykinetics of communication systems and their relationships to individual and collective 'body-machines' extended with new technology. The simple monolithic file cabinets are single bodies of a technological system linked together by computers and integrated into a giant network that functions as a world wide information reproduction machinery. The body as a transmission device, orgasmic contractions as kinetic control system, epileptic seizure of the body as information machinery.

Art works play with recognising simple and complex of systems, overlapping the physical and psychic space of the body, the living praxis, the city. Given the mass of signalling, the cacophony of billboards, vehicles, cupboards, drawers, on TV, where are we able to sense ourselves in an explicit way? In the gallery there is a stripping down of things (of a world that is potentially materially and psychically saturating), so that the discrete and the massive, the oblique and manifest, appear in relation. We are no longer required to be buried alive, or enveloped by a mass of things; we open ourselves up to correspondence.

Homeless praxis, surveillance and the ephemeral act-archive

Trace disperses the drive for the home to be a private domain, a castle, a retreat, the site of a family nucleus. The home appears as a shelter, for the ephemeral and as such homeless, in the sense that Trace fosters practices that need to move from place to place, that are of no fixed abode. In this way cultural legitimacy — propriety and property — is undermined. Instead of staking a claim[63], as said earlier, Trace constitutes a space for the conflation of living conditions, transcending the notion of public domain/private dwelling: reminding us to think who is at home where? Trace challenges parameters of belonging in the city.

When we walk down a street, or enter our house, we may feel alone, but the meaning of intimacy is quite different in age of hyper-surveillance and electronic transmitting apparatus. Of course, neighbours have always watched neighbours, and from now back to feudal times and beyond I imagine — the stranger has been a figure regarded with some suspicion. But it is largely the technology of documenting, recording and transmitting that has shifted the regulatory implications of tracing and observation, shifted the terms on which acts are interpreted, behaviours are profiled, judgements made and futures extrapolated.

Given the law, and the accelerating capacities of surveillance, the inviting of the stranger into the home is a political act, challenging economies of territory that result in segregation and territorialisation. When the invitation is to a meeting where we witness, and to varying degrees participate, in the relationship between action and archiving process that will eventually devolve itself, where our presence is called upon in the act-archiving event, a field of possibilities extends for our encounter;[64] Trace turns round the dynamic of the archive and domestic setting necessarily being separate, private and exclusive, a matter of un-seen storehouses, and things staying between four walls.[65] Documentary frameworks become 'open works'.[66] The power relations behind the city as a site of surveillance, signs of colonisation are shifted. Eyes are invited in and so the porosity of walls is realised, *willed*.

There is a re-siting of power relations in terms of collections of objects, the management of spaces, presence and absence in the home, archives and the city, yet not in terms of representation and document-ation, of altered images of containment. This is not so much a question of shifting the balance in equations, is

beyond staking a claim, standing by a record as a true account or setting the record straight. Installation art praxis at Trace does not re-trace history, or re-define presence, according to changed parameters of inclusion and exclusion. As I suggested in the introduction, as Trace has little to do with the logic of accumulation, its premise is not one of re-devising ways to make totals.

There is an actualisation of time and space on very different terms. Whilst specific issues of identity, and discursive frameworks that address them (feminism, postcolonialism...) may be invoked, a difference reson-ates in the actions of Trace with respect to absence, as a force through which the present unfolds. Trace situates loss, without preserving and transforming into a new thing to be held, kept, maintained. Not so much representing absence, as locating it as a force in our actions, minds, stories and rules, with all the reper-cussions that this may have in terms of the forms of our memories, the structure of histories, and the conditions of our day to day lives.

Some time ago, and in connection with my body of act-archiving work, I considered what in art history was referred to as the dematerialisation of objects, in relation to incidence of the re-materialisation of traces – and the occurrence of the ephemeral act-archive. Appearance and disappearance at Trace can be understood politically and poetically in the dynamic of these three terms.

Can we re-make a more accurate view of things? Any reckoning, whatever the laws for making such an account, has to deal with its own inbuilt bias. The making of history has been described as

a restorative act in which we discover from fragmentary survivals what may be inferred from them about a past which has not survived.[67]

But does the fragment need to be redeemed, in a whole? What lies in the wake of such memorials? The districts that encompass the museum, the monument, the data warehouse. When it is not so much a matter of seeking to objectify a perspective, deduce a solution, or create a new map, we may enter into a different human situation, a negotiation, fuelled by spirit, will and wherewithal. This is the non-alibi of re-making.

In conclusion: Documentary forms become discursive

It becomes clear Trace does not offer a site of redemption, for that would require a morality of a total version of things; the processes of the art works do not convey a solution, but a dissolution based on an opening up of the limits of our action, our ways of re-collecting. It posits itself not as improving, nor expanding, nor progressing – confirming the best values, giving the most significant accounts, housing the originals. Its logic at any moment, is the logic for re-making in the next. This ongoing siting/dislocation appears as a catalyst for motion. One could talk of a history of Trace, but this should not be taken for some kind of proof. There is a different attitude to the archive here: the commencement is not the commandment.[68] Its strength is that it does not remain and the possibility that this creates for bringing a sense of the emergence and receding of our selves, associations and relationships.

The scale of the works manifests their potential to place phenomena of shifting absence and presence in such a way as to remind us, not once and for all, but each time, of the humanity of loss seen in relation to the spectacle of gain. When the weight of the past is realised as a type of dynamic presence, our agency, as historical and living subjects, is re-called within a field of power relations, and the terms of engagement may shift.

The matter of what is represented and absented is more than an aesthetic or hermeneutic concern, rather it points us to an insufficiency that is a human issue, a

question of ethics. In the shadow of loss, the hollow excess of cabinets of guns, trench memorabilia and textboards about world wars is deafening. That that loss, or lack, recurs in an environment of mass production, hyper-representation, museum expansion, general surplus, and commensurate waste makes an emphasis on the dynamic of re-making all the more resonant. Similarly the intensely poetic and political significance of the fact that Trace is understood at the living room gallery as a process of ephemeral act-archiving, comes to the fore when we think how archives are developing. Now we increasingly document our lives en-masse through video and digital photography; there are projects to create 'Total Archives'[69] with swathes of data tracing all aspect of our known lives; Corbis and Getty Images are in the process of duopolising gigantesque stores of images, controlling dissemination by taking them out of circulation in underground vaults. What is remembered when we do not seek to remember, to record, to contain? What is forgotten amidst this mass of divisions?

Zones in the city are set out on the bases of regulation of past time and present time. When we think carefully about where we go, we recognise the intent that quite specific tasks and behaviours are exerted there, highly targeted messages and interpretations are conveyed. The control of the terms of entry and access and passage through physical spaces − and the atmosphere that results − reports to an ethos of ordering the experience, exchange, production and acquisition of knowledge, goods and symbols, which, piece by piece, portray status. Thus the parameters of the museum, home, street, archives... It is important to stress that Trace does not constitute an 'in-between' space − a modelisation that emphasises a bridging between divides. Trace renders these designated areas fluid by conflating the processes through which their conditions are established. The gallery creates opportunities where we can be in the city on different terms, of intimacy, of strangeness, of ambiguity, of intensity. The art works create conditions for some things to be together that would otherwise remain apart, undisclosed, and as such invasive. Meetings and departures at Trace precipitate crises of legitimacy: documentary forms, commodified interactions, and the mindset of containment become discursive forms. Imagining within and without the walls, we see convergence and dispersal, a porosity of our thoughts and bodies, that is both conceptual and actual.

Notes

1 This term is useful because it carries the combined sense of:
 i The act or process of arranging: the arrangement of a time and place for the meeting.
 ii The condition, manner, or result of being arranged; disposal: provided flowers and saw to their arrangement.
 iii A collection of things that have been arranged: the circular arrangement of megaliths called Stonehenge.
 iv A provision or plan made in preparation for an undertaking. Often used in the plural: for surgery.
 v An agreement or settlement; a disposition: Our dog will be looked after by arrangement with a neighbour.
 vi Music:
 a An adaptation of a composition for other instruments or voices or for another style of performance.
 b A composition so arranged.

2 I first used this term in an artist statement from 1999 to refer to the exploration, in interdisciplinary performance and installation works that I was making, of the relationship between live presence in the art work (that of the artist and others) and processes of historicisation.

3 I use this verb given the programmatic implications of its definition: To bring into a harmonious or responsive relationship. Whose idea of harmony?

4 A dynamic focus means:
 i Of or relating to energy or to objects in motion.
 ii Characterised by continuous change, activity, or progress.
 iii Marked by intensity and vigour; forceful.
 iv Of or relating to variation of intensity, as in musical sound.

5 www.dictionary.com (11/10/2005).

6 www.dictionary.com (10/10/2005).

7 With the huge capital injection in building programs, expanding existing premises, there is no reason to think that this premise/mindset is changing.

8 From André Stitt's introduction to the gallery at www.tracegallery.org (10/10/05).

9 Entitled *Trace: The Domestics of Art*, published by Trace, Cardiff (online at www.tracegallery.orgarticles/domesticsofart.htm), which first appeared, in French, as 'Trace et les zones hétèrogènes de l'art' in *ESSE Arts+Opinions* journal, No. 42, (Montreal, 2001).

10 In Andrew McClellan, Ed., *Art and Its Publics: Museum Studies at the Millennium*, Blackwell Publishing (Oxford, 2003)

11 Ibid., p.77.

12 These include the emergence of the museum from the temple in antiquity, the rise of the museum in Europe following the spread of Enlightenment values of universal improvement, and the expansion in the number and size of museums prompted by Victorian values, of charity and patronage. These are linked to the prescription of the grounds of citizenship, hegemonic ideas of improvement, and colonisation.

13 Foucault... points to the emergence of theory among the Greeks as the great turning point in our history. The pragmatic and poetic discourse of early Greek civilisation was destroyed by the rise of theoretical truth: "The Sophists were routed ... [from] the time of the great Platonic division onwards, the [Platonic] will to truth has had its own history..." http://istsocrates.berkeley.edu/~hdreyfus/html/paper_being.html (10/10/2005).

14 Paul Hamilton, *Historicism*, Routledge (London, 1996) p4.

15 The modernising, civilising drives celebrated in the museum are inextricably linked to preservation and analysis.

16 Equally by performance and installation. This is the focus of my ongoing doctoral research *Re-collecting the Poetry and Politics of Archival Spaces: An exploration of Performance and Installation Art in the Museum* (Ulster University, Belfast, 2002).

17 As methodologies that potentially embody research, performance and installation go beyond the necessity of having either on site immediate experiences or detailed and elaborated off-site studies. The art work is potentially both immanent and investigative.

18 Hamilton, Op. Cit., p37.

19 Ordure, dirt: anything unclean; Abfell: scrap, remnant, waste http://www.tracegallery.org/artists/stuart_brisley/index.htm (10/10/2005).

20 Dilston Grove Church, London, October 2001. Curated by André Stitt and Roddy Hunter.

21 Anyone who has ever performed a dance with museum invigilators around a gallery has had an immediate sense of this tension. Showing a lot of interest in one object, even when standing relatively far away from it, will invite imposing monitoring; being too interested starts the motor of museum interest turning. There is an amount of time we view for, a range of positions from which it is normal to view, giving us cause to consider the scope of what we can see, and encounter, in such physical and psychic conditions.

22 http://www.museum-ordure.org.uk (10/10/2005).

23 Season 3, January 2004 www.tracegallery.org (10/10/2005).

24 From the essay If We Take, Care: On the Suicide of Objects (Mythology and Obsolescence) p.52, in Julie Bacon, Ed., *The Suicide of Objects*, (publ. Belfast; Catalyst Arts, 2004): a catalogue of an event that I curated in March-April 2004, featuring art works that explored archival processes, presented at Catalyst Arts, the Ulster Museum and sites in Belfast city centre.

25 Ibid., p52-53.

26 That is mortality.

27 Published in Kristin Stiles, Peter Selz, Eds., *Theories and Documents of Contemporary Art: A Sourcebook of Artists' Writings* (University of California Press; 1996).

28 Which he traces to the theme of destruction in Cubism, Futurism and Dada.

29 Coracle Press (London; 1996).

30 Just as Brisley invites us to consider differently the proposition of waste management so Metzger reminds us that as far as waste products are concerned the logic is "we'll dirty it up then we'll clean it up". Ibid., p21.

31 Presenting a whole whose legitimacy is questioned if the indexing system disappears, as Douglas Crimp suggests in On the Museum's Ruins, in Hal Foster, Ed., *Postmodern Culture* Pluto Press (London; 1990).

32 To understand this interplay we might think of the philosopher Martin Heidegger's concept of clearing, discussed in *The End of Philosophy and the Task of Thinking*. "Heidegger devotes many pages to showing that, although the pre-Socratics did not think about the clearing, they did not deny it either. They sensed that showing up or presencing depended upon what was absent or withdrawn. But this understanding was lost when Plato took the Good to be the purely present ground of the phenomena, and truth to be the correspond-ence of theoretical propositions to an independent reality." http://ist-socrates.berkeley.edu/~hdreyfus/html/paper_being.html (10/10/2005).

33 Or dualities. Heidegger's approach contests this way of thinking, which he argues was set in motion by Plato.

34 In his Historic Photographs installation, Metzger creates works that are partly hidden and revealed through our interaction with them. We crawl under a sheet, peer round the side of boxed-in images – they are on show and not on show. The installation, performed by the audience, stresses partiality, bias, gives physical form to our intention to view, turning it into an act of witnessing: a decision has been made, you have been crossed over from a space where you are simply surrounded by images to one where you intend to see them. This is arguably a distinction of those who visit Trace to see the works: a kind of private-public agreement.

35 Sage Publications (1999).

36 Paul Hamilton, Op. Cit. p118.

37 For instance, digital materials have greater obsolescence, partly because they require apparatus to record and read, than products of hand-made technology.

38 Whilst forms of representation are part of 'human condition', the monument is not a form that innately is understood. What can we take for granted, as read?

39 At Trace in Season 1, Dec. 2000.

40 At Trace in Season 5, May 2005.

41 Meaning:
 i a length of yarn or thread wound loosely and coiled together
 ii a flock of wild birds flying across the sky in a line
 iii a tangled or complex mass of material
 Encarta World English Dictionary © 1999 Microsoft Corporation.

42 At Trace in Season 4, Jan. 2004

43 Ibid.

44 At Trace in Season 1, April 2001 http://www.tracegallery.org/artists/dan_mckereghan/index.htm (10/10/2005).

45 There are few shared spaces like this in which we find ourselves, even the home.

46 See *Liberating the Mind From Orthodoxies in Propaganda and the Public Mind: Conversations with Noam Chomsky*, South End Press www.southendpress.org.

47 http://www.tracegallery.org/artists/HighHeelSisters/index.htm (10/10/2005).

48 This relates to the Situationist International strategy of the dérive, and discussion of the flâneur by Benjamin.

49 At Trace in Season 4, Dec. 2003.

50 http://www.tracegallery.org/artists/jimmie_durham/index.htm (10/10/2005).

51 At Trace in Season 3, May 2003.

52 http://www.tracegallery.org/artists/louise_liliefeldt/index.htm (10/10/2005).

53 At Trace in Season 5, May 2005.

54 http://www.tracegallery.org/artists/CoseyFanniTutti/index.htm (10/10/2005).

55 It was Henry David Thoreau, who sugested, in his book *Walden* (1854) that "The mass of men lead lives of quiet desperation and go to the grave the song still in them".

56 Ambiguity is a release from dogma.

57 At Trace in Season 2, Feb. 2002.

58 http://www.tracegallery.org/artists/julie_andree_trembley/index.htm (10/10/2005).

59 At Trace in Season 2, April 2002.

60 At Trace in Season 1, Jan. 2001.

61 http://www.tracegallery.org/artists/jamie_mcmurry/index.htm (10/10/2005).

62 At Trace in Season 3, Oct. 2002.

63 A drive-in culture that, at least as long as Westerns are re-run, seems to hark back to the mythology of the goldrush era.

64 Archiving in the expanded field, to echo Rosalind Krauss's 'Sculpture in the Expanded Field'. In Hal Foster, ed., *Postmodern Culture*, pp. 31-42. Pluto Press (London; 1985).

65 It was my intention to highlight this, and further conflate the home/archive in the installaction that I presented at Trace in which I re-made the bookshelves fitted into the roof of the attic room of my home, and transported key contents between the sites. With its weighty storage and auto-biographical function freed up somewhat, the structure in Trace enabled movement that the home did not, literally the possibility of scaling, moving through over and on the archive.

66 To echo Umberto Eco's *The Open Work (Opera aperta)* translated by Anna Cancogni, Harvard University Press (Cambridge, 1989).

67 Oakeshoff cited by Paul Hamilton, Op. Cit. p.17.

68 As Jacques Derrida explains in *Archive Fever: A Freudian Impression*, Chicago & London (University of Chicago Press; 1996), this is the founding principle of the archive: 'Archive or arkhe, we recall, names at once the commencement and the commandment. "This name apparently co-ordinates two principles in one: the principle according to nature or history, there where things commence – physical, historical, or ontological principle – but also the principle according to the law, there where men and gods command, there where authority, social order are exercised, in this place from which order is given-nomological principle" p.1.

69 For a discussion of this, see the journal *Parachute*, Extra Human-AI issue, 119, July-Sept 2005 (Montreal; 2005)

Notes on Contributors

André Stitt

www.andrestitt.com

Born in Belfast, Northern Ireland, Stitt is considered one of Europe's foremost performance and interdisciplinary artists. He has worked as a time based artist since 1976 creating hundreds of unique performances at major galleries, festivals, alternative venues and sites specific throughout the world. After living in London for nearly 20 years he relocated to Cardiff in 1999 to become head of the Time Based Art course at Cardiff School of Art. In 2004 he became a professor of the University of Wales.

Dr. Heike Roms

www.performance-wales.org

Dr Heike Roms is Lecturer in Performance Studies at the University of Wales Aberystwyth. She has published widely on contemporary performance practice, in particular on work originating from Wales. Current projects include a history of Welsh performance art and a book on the relationship between performance and ecology in a Welsh context. Heike has collaborated with a number of Welsh artists on a variety of performance works and is involved in several artist-run projects and networks in Wales. She has lived in Wales since 1995.

Julie Bacon

Julie Bacon is currently based in Belfast, where she is co-director of Catalyst Arts. She is also a researcher at the University of Ulster and is in the process of completing a Phd at the university: *Re-collecting the poetry and politics of archival spaces: An exploration of performance and installation art in the museum.* She publishes texts about art and is currently putting together a collection of her poetry entitled *A Signal-noise mix.*

Jimmie Durham

An internationally renowned artists and teacher currently based in Berlin, Durham has contributed many texts on the discourses of contemporary art for periodicals, catalogues and art publications. He has had several books published including *Stone Art*, CCA, Japan 2001 and *Between The Furniture and The Building*, Walther Konig, Germany 1998. There are several books about his art by major international publishers Phaidon and Cantz.

Trace Team 2000-2005

Artistic Director
André Stitt

Board Members
Phil Babot
Heike Roms
John Hambley
Eddie Ladd
Hannah Firth

Honorary Members
Stuart Brisley
Cosey Fanni Tutti
Martha Wilson
Stelarc
Alastair MacLennan
Jimmie Durham

Gallery Interns
Kim Simons
Liz Hurrell

Photography
Phil Babot
Robert Girard
André Stitt

Video
Tim Bromage
Heddwyn Davies
Simon Mitchell
James Errington
Duncan Sturrock

Technical Support
Julian Kelly
Neil Pedder

Trace would like to thank the following individuals and organisations:

Chris Ricketts
Anthony Owen Hicks
Emma Geliot
Tim Coward
Richard Martel
Colin Hicks
Chris Coppock
Johanna Ekornes
Carol Robertson
Mike Pearson
Monica Ross
Julie Fiera
Paul Granjon
Jennie Savage
Sally Hughes
Simon Mitchell
Diane Paulse
Ben Ponton
Lee Callaghan
Anthony Roberts
James Tyson
Shu Yang

Arts Council of Wales
Wales Arts International
British Council
Cardiff 2008
Cardiff School of Art & Design
Time Based Practice [Cardiff]
Delegation of Québec in London
Conseil des arts et des Lettres Québec
Ville de Québec
Canada Council for the Arts
Canadian High Commission, London
Experimentica
Chapter Arts Centre
Lee Foundation [Singapore]
Arts Council of Northern Ireland
Scottish Arts Council
Mondriaan Foundation
Office of Contemporary Art Norway
International Artists Studio Programme, Sweden
University of Northern Iowa
Ulster University
Dartington College of Art
FRAC Basse-Normandie
Culture Communication Republique Francais
Le Lieu Centre en art Actual
INTER magazine
Dadoa Live Art
Beijing New art Project
Franklin Furnace Archive, New York

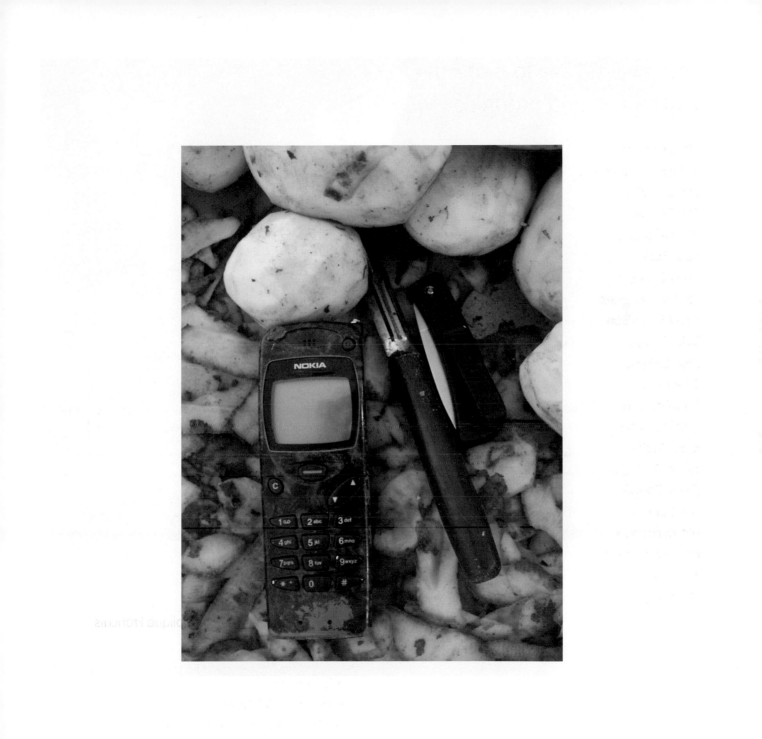

Index

Abramovic, Marina 35

Agamben, Giorgio 30

Arnell, Malin 116-7

Artes Mundi 22

Artists' Project 25

Babot, Philip 20, 21, 23, *130, 132tl,* 133, 133, *139t,* 141, *140tl*

Bacon, Julie 30, 34, 108-9, *142,* 158

Baillargeon, Annie 137

Baker, Bobby 28

Bala, Iwan 18, 19, 20, 21, 36

Baren, Peter 114-5

Barlow, Martin 19

Barry Summer School 18

Bauman, Zygmunt 149

Beca 19

Beres, Jerzy 16, 31, 66-7

Blake, William 147

Bloc 25

Bodenham, Pete 20

Boehme, John G. 31, 34, 52-3

Bouchard, Carl *134b,* 137

Bowie, David 8

Brecht, Bertolt 9

Brisley, Stuart 16, 34, 58-9, 126-7, 145, 147-50, 161

Brith Gof 19, 21

Buege, Jessica 16, 34, 50-1

Byrd, Jeffery 98-9

Cage, John 12

Cameron, Shirley 18

Cardiff Art in Time (CAT) 23

Cardiff Projects 25

Cardiff School of Art and Design 22

Catlin, Bobdog *68,* 82-3

Chance, Michael Le 137

Chapter Arts Centre 24, 27, 31

Charest, Melissa 137

Christo 23

Clay, Rawley 21

Cliche, Eugenie 137

Cobb, James *68,* 82-3

Coed Hills Rural Artspace 21

Con, Rob 18

Connolly, Brian 31, 35, 62-3

Cook, Matt 23, 133, *133t, 136tr, 138tr,* 139, *139b*

Corbis 156

Cotton, Claudine 31, *134tr,* 136

CPR Centre for Performance Research 26

Crockett, Davy 36

Cywaith Cymru 19

Daily Express 18

Daily Telegraph 18

Davies, Ivor 18

Davies, Paul *14,* 17-8

Davies, Tim 19

Deacon, Robin 23

Dedomenici, Richard 23

Deller, Jeremy 23

Dent, Eve 23, 27-8, 31, 34, 42-3

Derrida, Jacques 28

Destruction Art 18

Domke, Graham 9

Dufrasne, Martin *134b,* 137

Durand, Guy Sioui *135b,* 137

Durham, Jimmie 36, 92-3, 145, 152, 160

Eisteddfod, National 18-9

English, Rose 12

Fielding, Kim 24

Finnemore, Peter 19

Flood, Mik 24

Fluxus 17

Foucault, Michel 17

Franklin, Benjamin 36

Freud, Sigmund 27

Fuller, Samuel 21

G39 24

Getty Images 156

Gilbert and George 12

Goat Island 23

Gomez-Peña, Guillermo 26

Good Cop Bad Cop 25

Gough, Richard 26

Granjon, Paul 23, *137b*

Grey Suit: Video for Art & Literature 23

Hadid, Zaha 22

Harris, Annie *132tc,* 133

Hassall, Lee 48-9, 141, *141t*

Hastie, David 19

Hazelden, Maura 20

Heidegger, Martin 158

Henderson, Kevin 31, 34, 110-1

Heng, Amanda 31, 96-7

High Heel Sisters *104,* 116-7, 145, 152

Hill, Gary 23

Hinchliffe, Ian 18

Hourahane, Shelagh 18

Howard Gardens 22-4

Howell, Anthony 23

Hsieh, Tehching 28

Hunt, Albert 8-9

Hunter, Roddy 28-9, 34, 94-5, 145, 148, 150

Hurley, Paul 23, 141, *141b*

Jarman, Odilia 133, *133b*

Jeff, Paul 25

Jones, Bryan 24

Kantor, Istvan 31, 70-1, 145

Karlstrøm, Line S. 116-7

Katzenstein, Uri 106-7

Kinsey, Christine 24

Ladd, Eddie 13, 21, 24 *136b,* 161

Laplante, Myriam 31, *86,* 90-1

Le Lieu 16, 137, 162

Lepetit, Cyril 118-9

Les Fermières Obsédées *135t,* 137

Liliefeldt, Louise 84-5, 145, 152

Locws International 25

Mackenzie, Jordan 76-8

Marshall, Glyn Davies 74-5

Martel, Richard 135, 162

McCarthy, Danny 100-1

McKereghan, Dan 52-3

McMurry, Jamie 46-7, 145, 153

MacLennan, Alastair 8, 15, 30, 40-1, 161

Merz, Mario 17-9

Messier, Christian *134tl,* 137

Metzger, Gustav 145, 149-50, 158

Miller, Roland 18

Mitchell, Simon 24-5, *132br,* 133, *136tc, 138tl,* 139, 161

Morefront 24

Morgan, Richard 25, *132tr*

Muñoz, José Esteban 34

Nash, Paul 20

Newman, Hayley 23

Nieslony, Boris 34, 120-1, 150

O'Donnell, Hugh 31, 112-3

O'Donnell, Sinéad 31, 112-3

O'Hara, Morgan 35, 64-5, 135, 153

O'Reilly, Kira 23, 29, 31, 35, 44-5, 150

Oliver, Barnaby 20

Ono, Yoko 16

Optimist, Irma 72-3, *163*

Padin, Clemente *122,* 124-5

Palma, Brian de 21

Pane, Gina 35

Partaik, James 31, 32, 88-9

Pearson/Brookes 25

Performance Research 26

Perreault, Nathalie 137

Phelan, Peggy 26

Piper, John 20

Plaisance, Catherine 137

Prendergast, Peter 20

Quarter, The 25

Rees, Marc 21, 24

Rees, Sara 27, 28

Reich, Steve 23

Rhwnt 16, 31, 89, 134-7

Rice, Danielle 146-7

Rogers, Richard 22

Roms, Heike *135b*, 137, 160

Rowley, John 25

Sager, Peter 36

Santayana, George 150

Savage, Debbie 9, 24

Savage, Jennie 25, 137, *137t*, 162

Schechner, Richard 26

Schneider, Rebecca 26

2nd Wednesday 26

Sherman, Stuart 23

Shimoda, Seiji 23, 102-3

Shirai, Hiromi 31, 78-9

Sisley, Alfred 20

Smitty *56*

South Wales Echo 18

Station House Opera 23

Stensland, Karianne 116-7

Stevens, Gary 23

Steward, Stirling 20

Stitt, André 12-3, 16, 19, 23, *122*, 133, 135, *135b*, *136tl*, *138b*, 139, *140tr*, 141, 153, 158

Sturrock, Duncan *132bl*, 133

Sustrans 49

SWICA 25

Sydney Biennale 93

T., Julie Andrée 16, 32, 34-5, 60-1, 145, 153

tactileBOSCH 24, 28

Theatre of Mistakes 23

Torrens, Valentin 31, 80-1

Trailerpark 25

Tse-Tung, Mao 141

Turner, JMW 20

Tutti, Cosey Fanni 16, 128-9, 161

Tyson, James 24, 162

Umbrella Group 25

Venice Biennale 93

Warpechowski, Zbigniew 16, 35, *56*, 66-7

Washington, George 36

Webster, Catrin 20

Whitehead, Simon 19-20, 24

Whitman, Walt 36

Williams, Emmett 12

Williamson, Aaron 23

Wood, Denis 36

www.tracegallery.org